SMALL WARS

SMALL WARS
AN-MY LÊ

aperture

VIÊT NAM 08
SMALL WARS 40
29 PALMS 70

ESSAY by Richard B. Woodward 108
INTERVIEW with Hilton Als 118
BIOGRAPHY 126

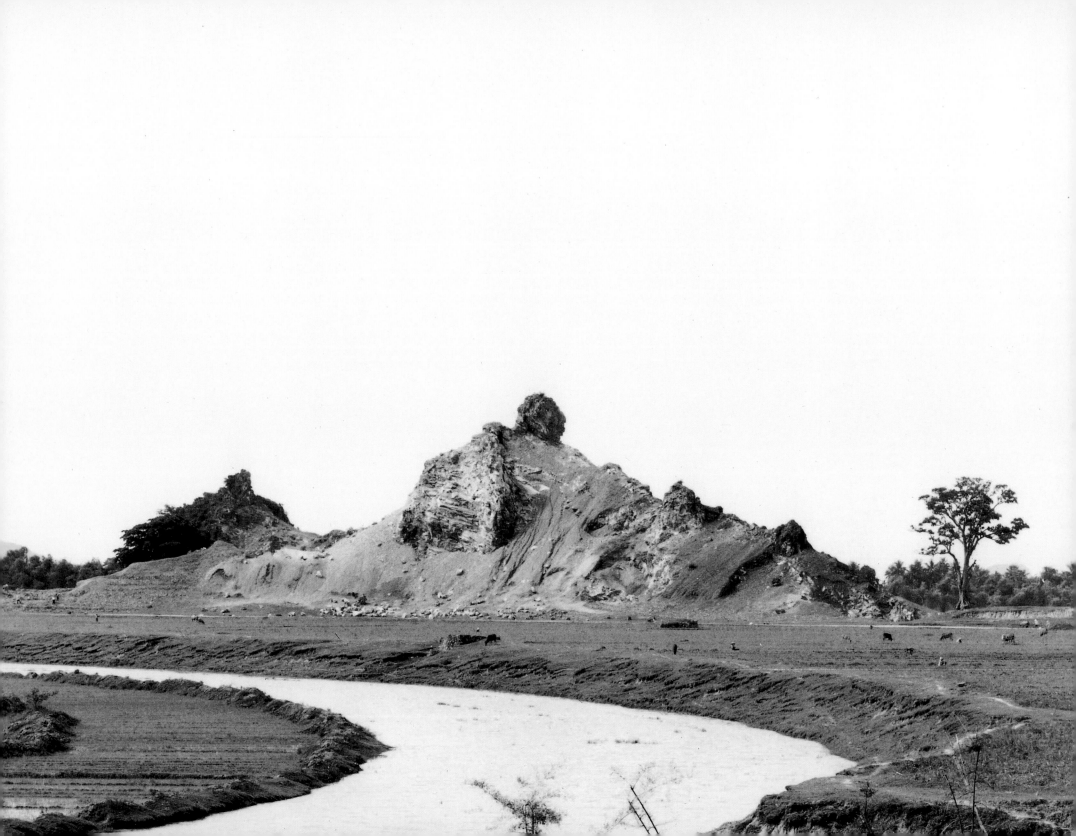

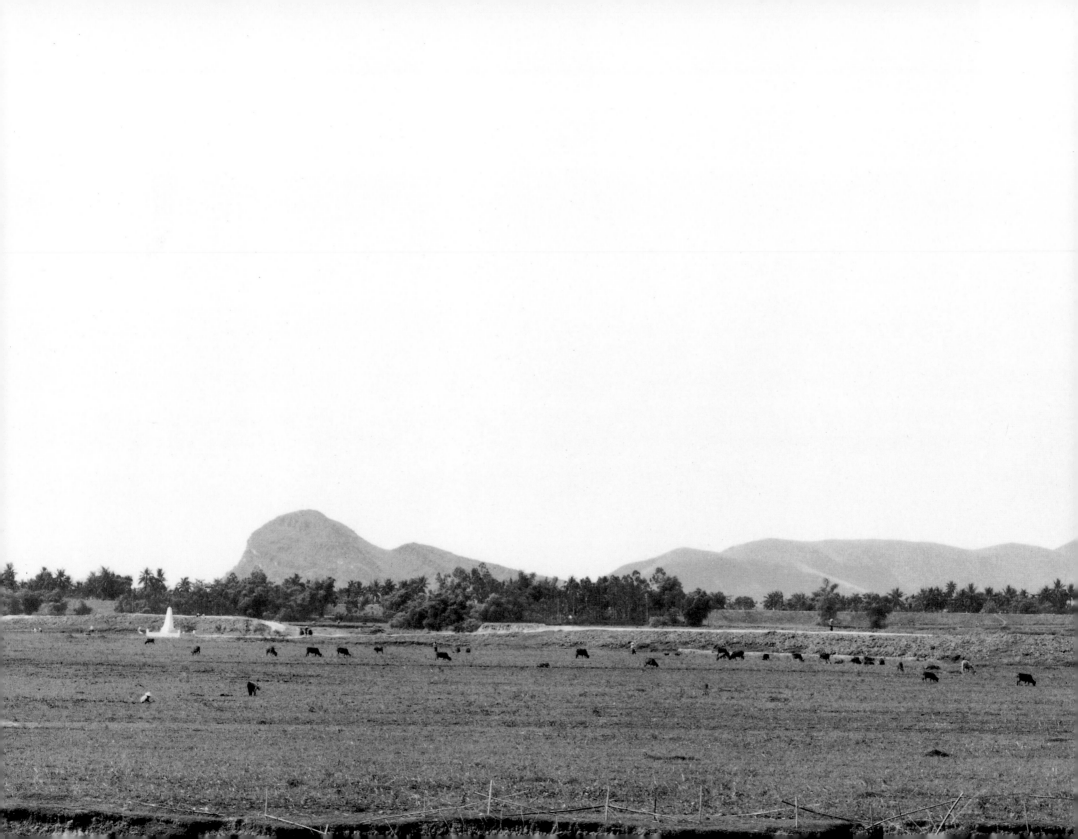

VIÊT NAM

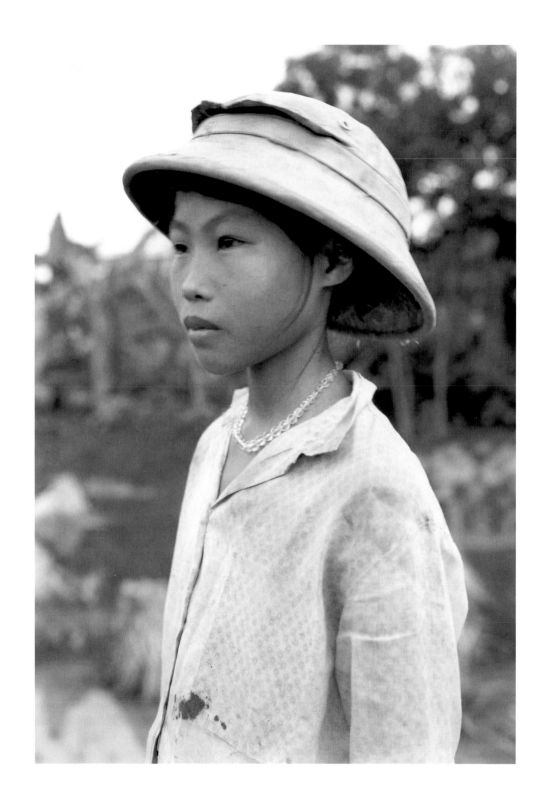

9 *Untitled, Nam Ha, 1994*

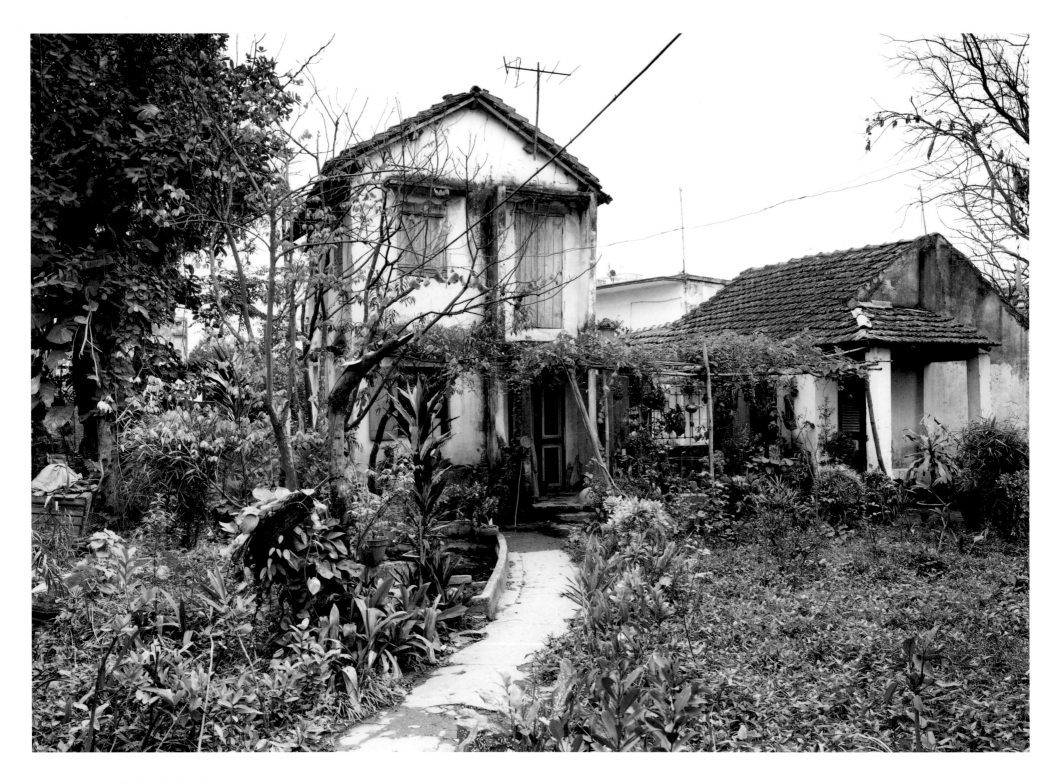

Untitled, Hanoi, 1996

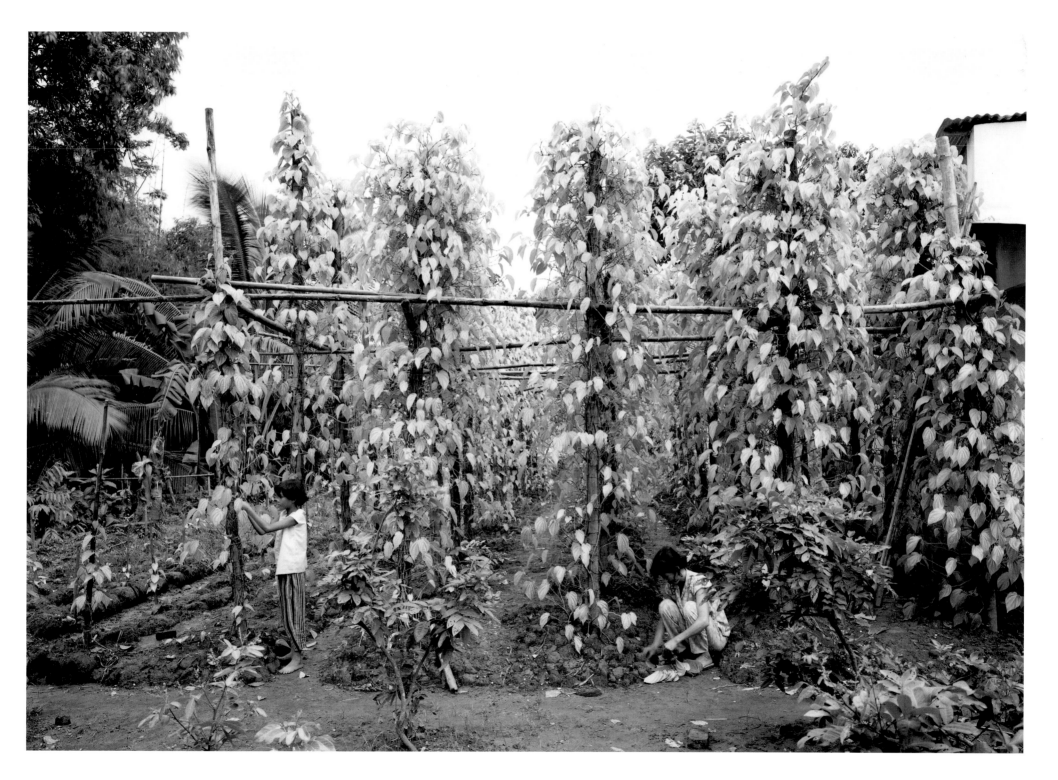

11 *Untitled, Mekong Delta, 1995*

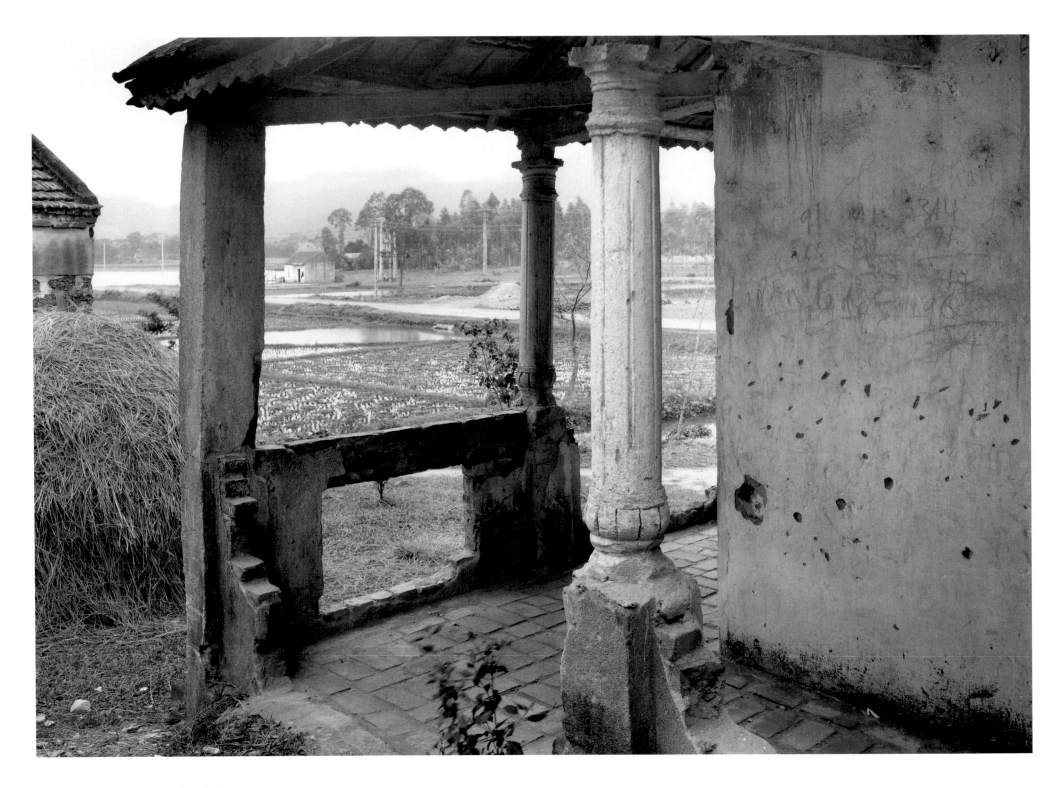

12 *Untitled, Soc Son, 1996*

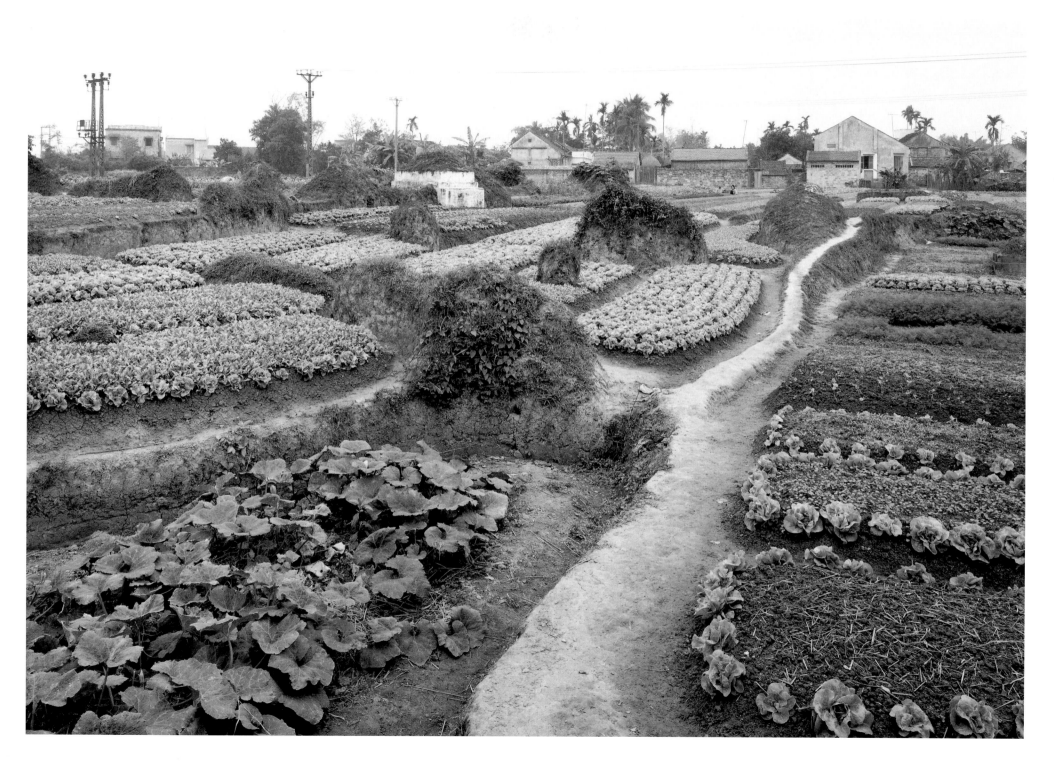

13 *Untitled, Son Tay, 1998*

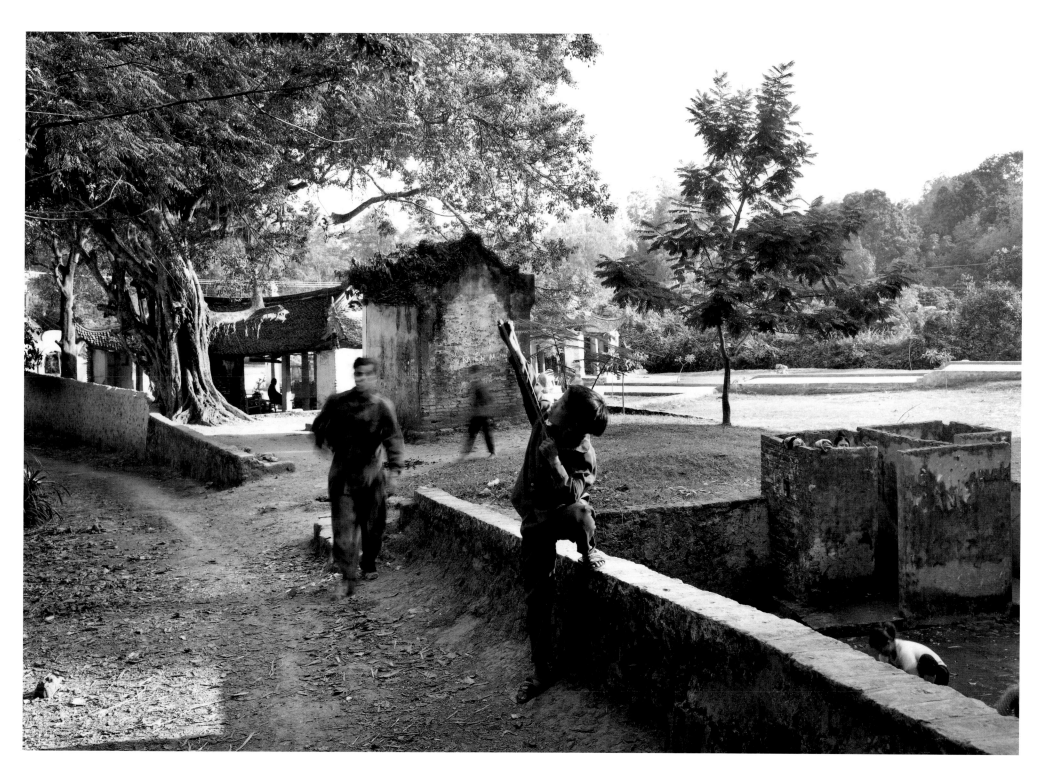

15 *Untitled, Tien Phuong, 1995*

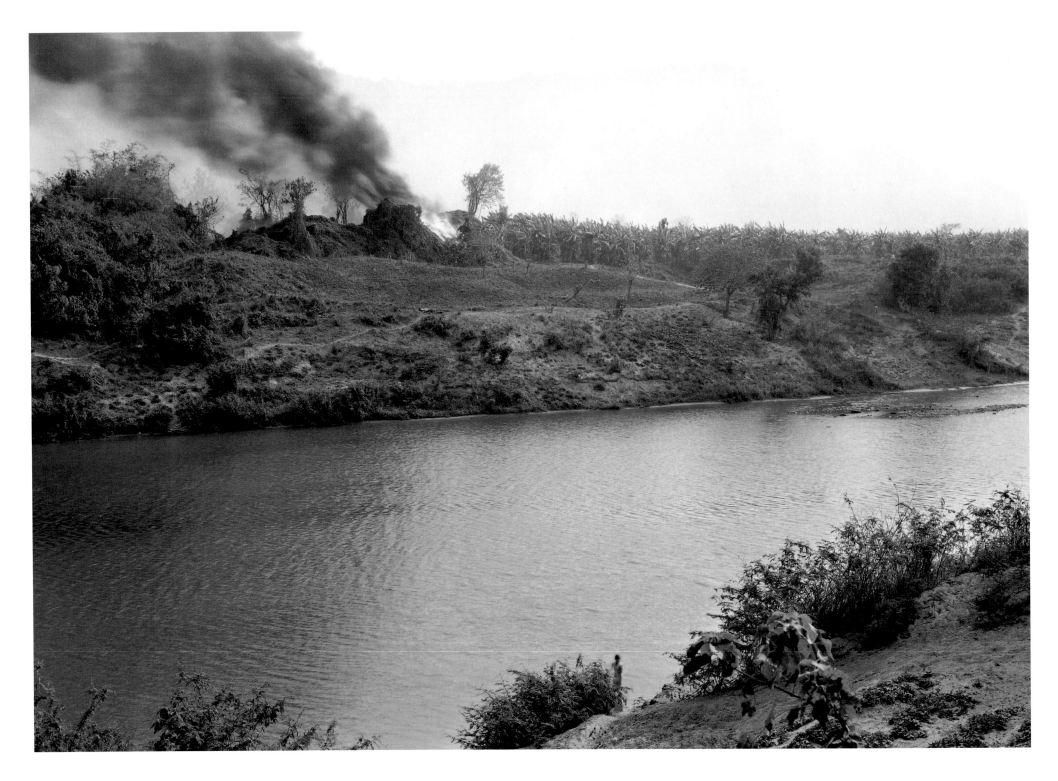

16 *Untitled, Lao Bao, 1998*

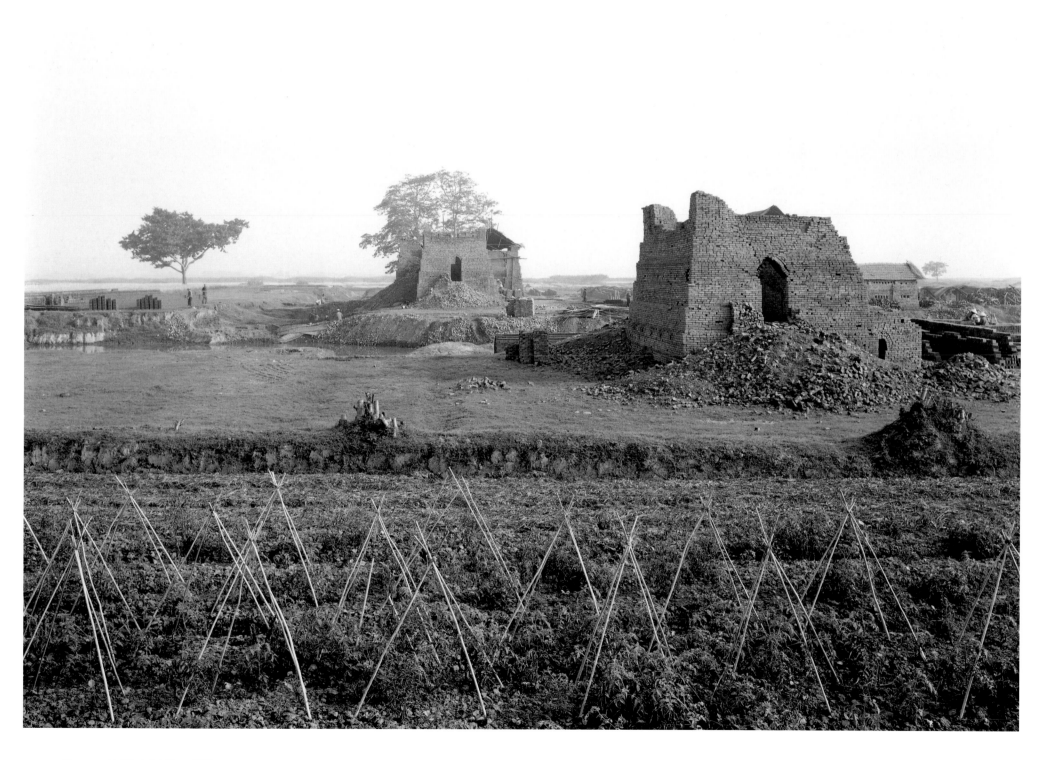

17 *Untitled, But Thap, 1996*

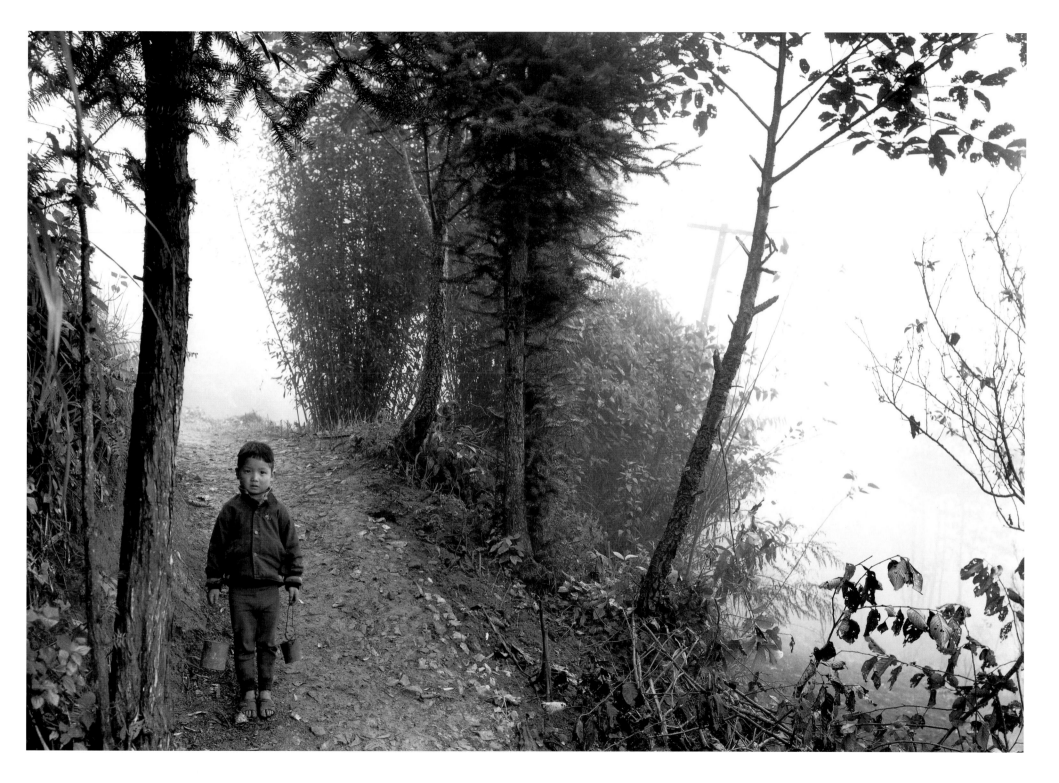

Untitled, Sapa, 1995

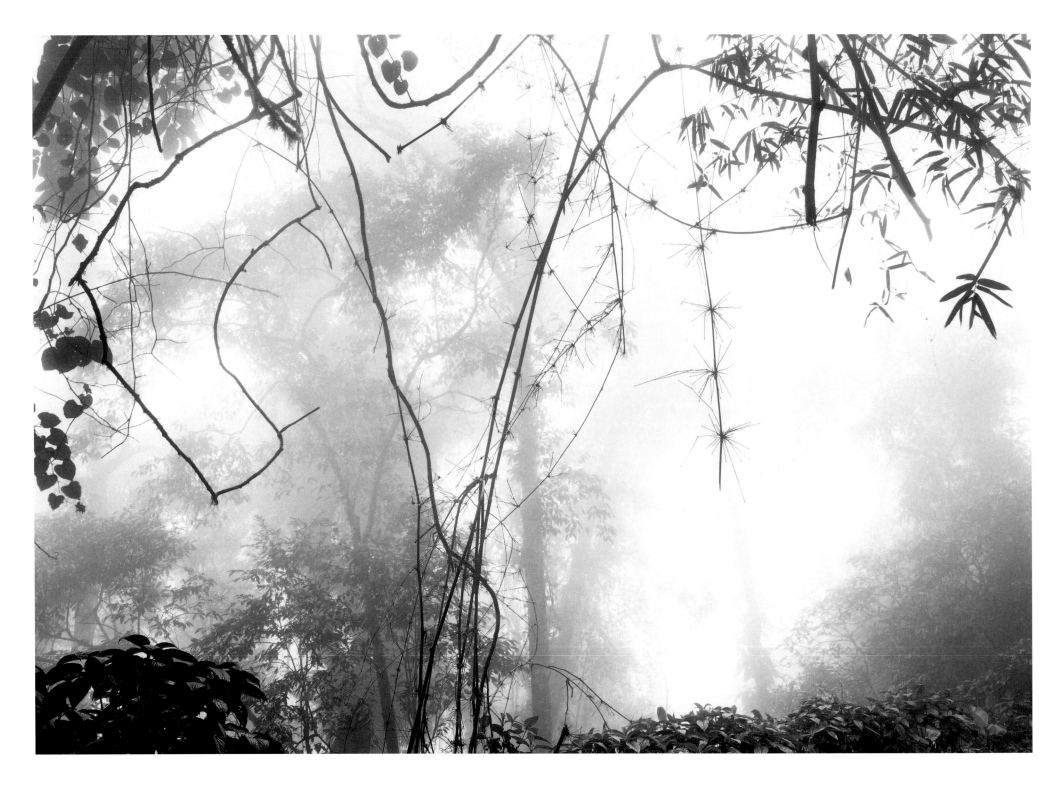

20 *Untitled, Ba Vi, 1998*

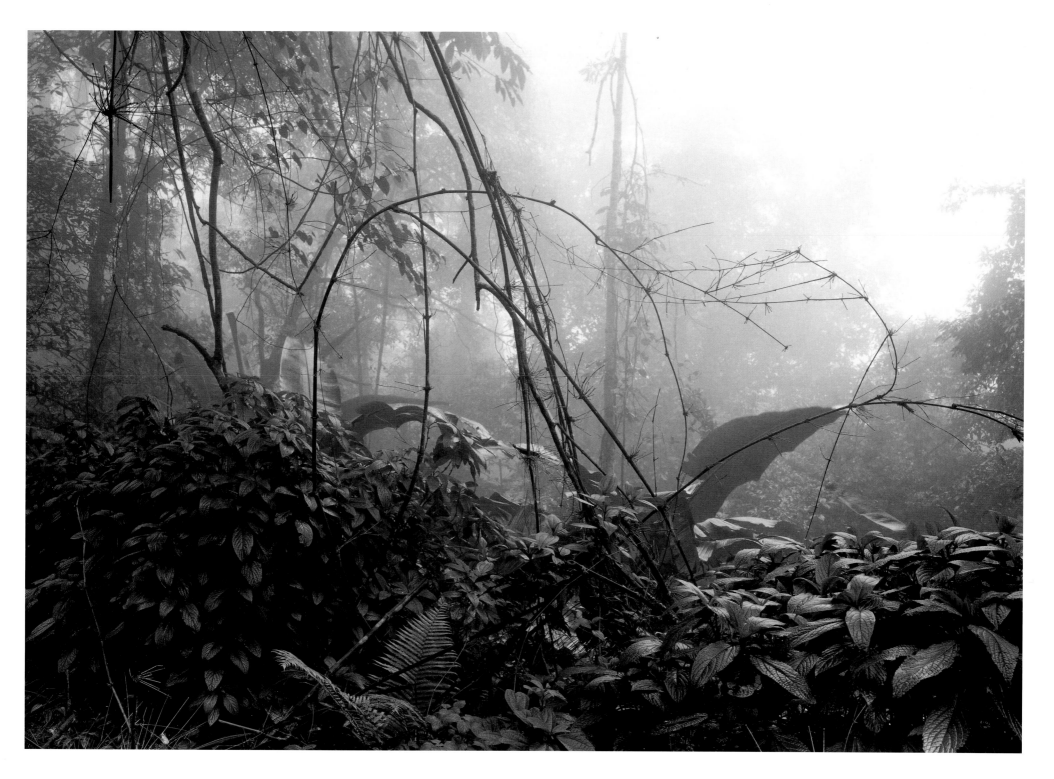

21 *Untitled, Ba Vi, 1998*

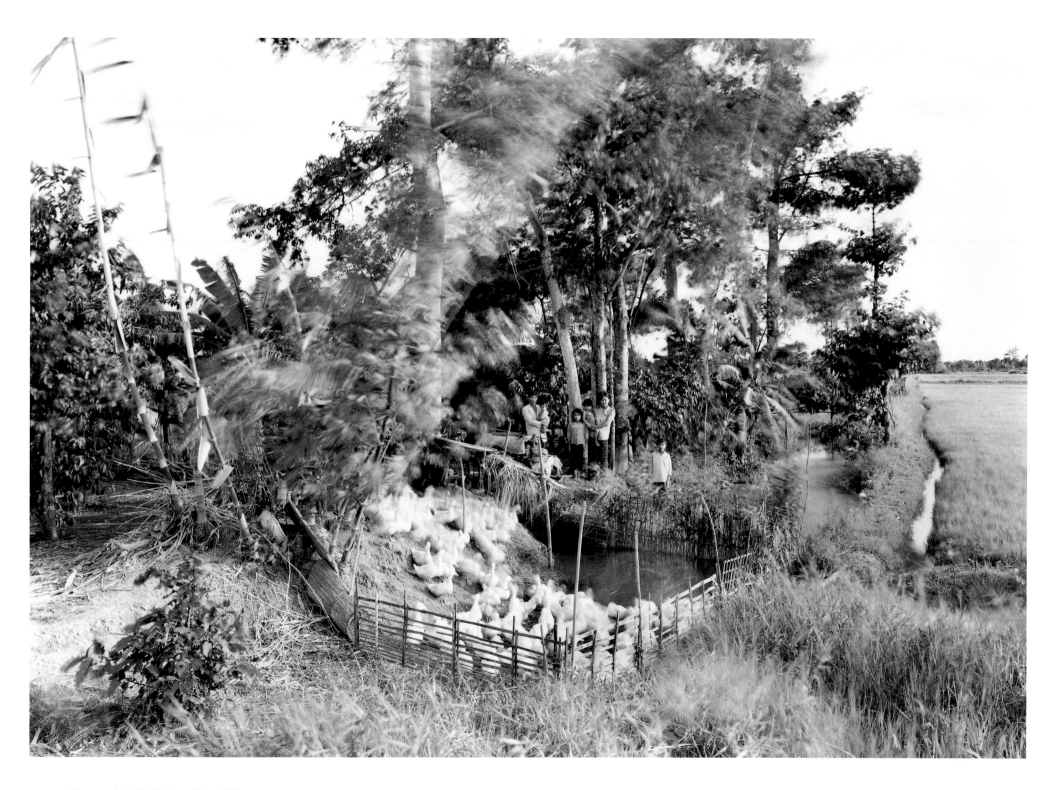

23 *Untitled, Mekong Delta, 1994*

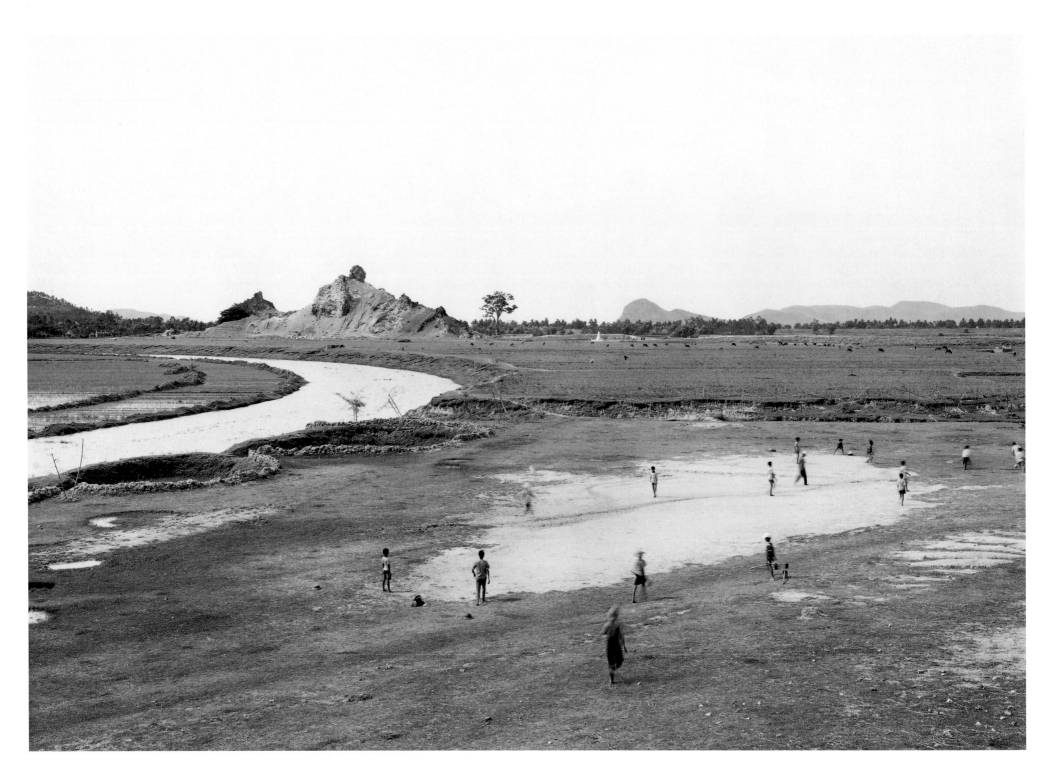

24 *Untitled, Thanh Hoa, 1998*

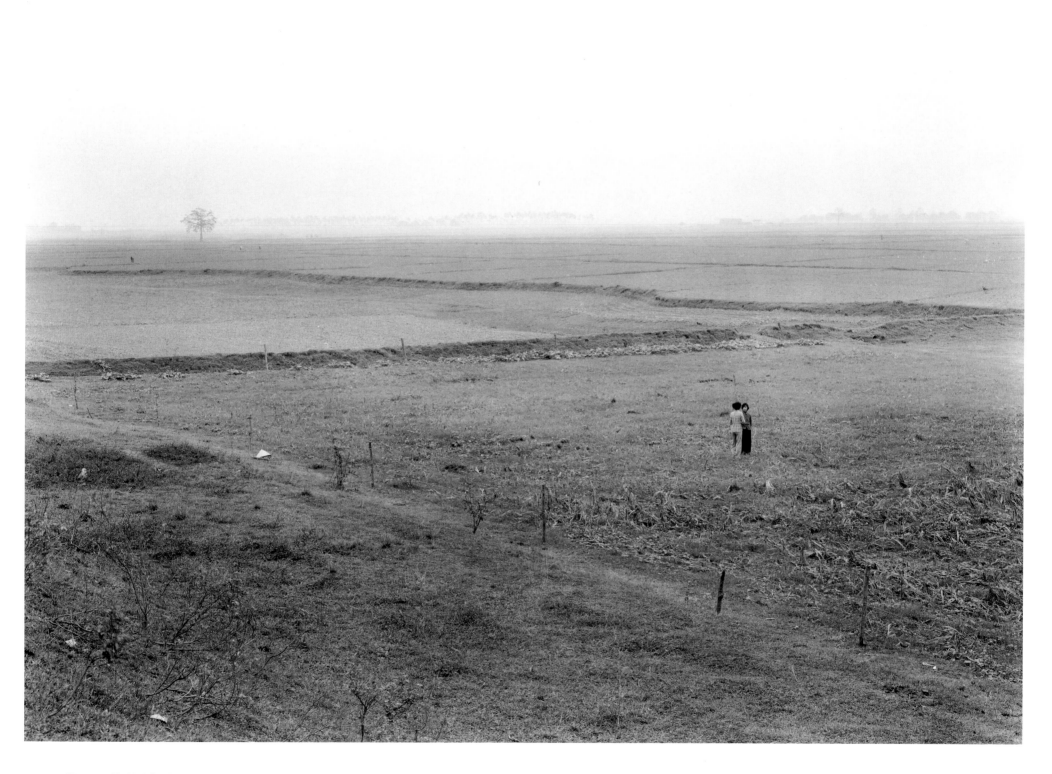

Untitled, But Thap, 1998

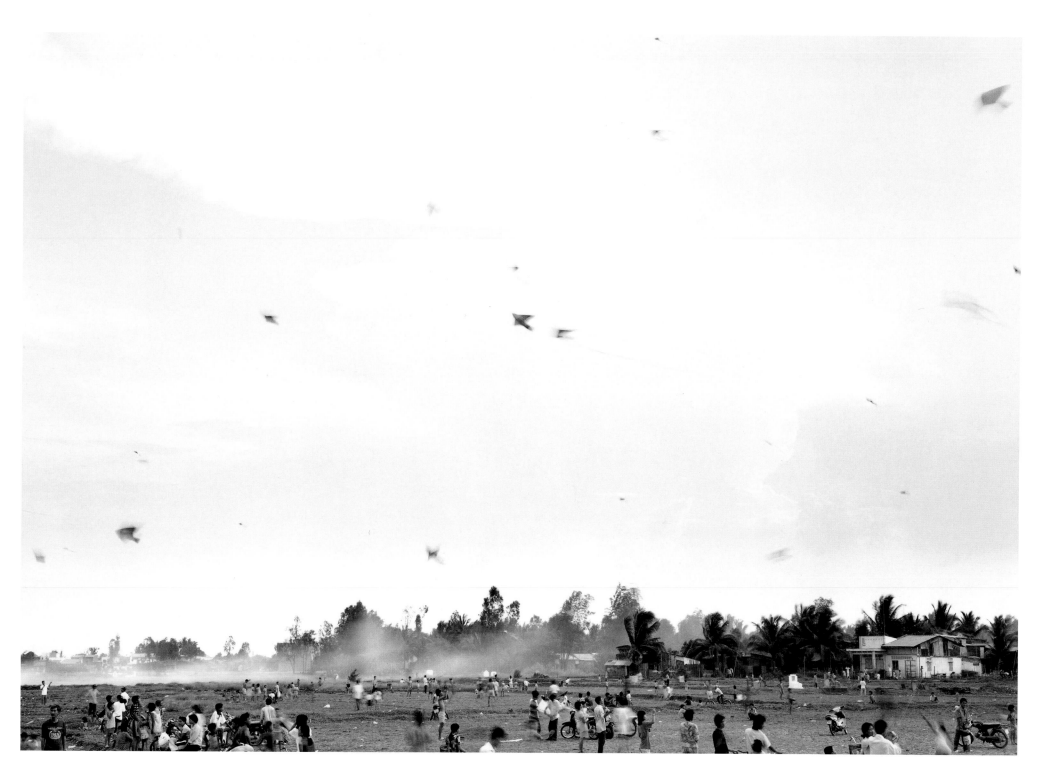

27 *Untitled, Ho Chi Minh City, 1998*

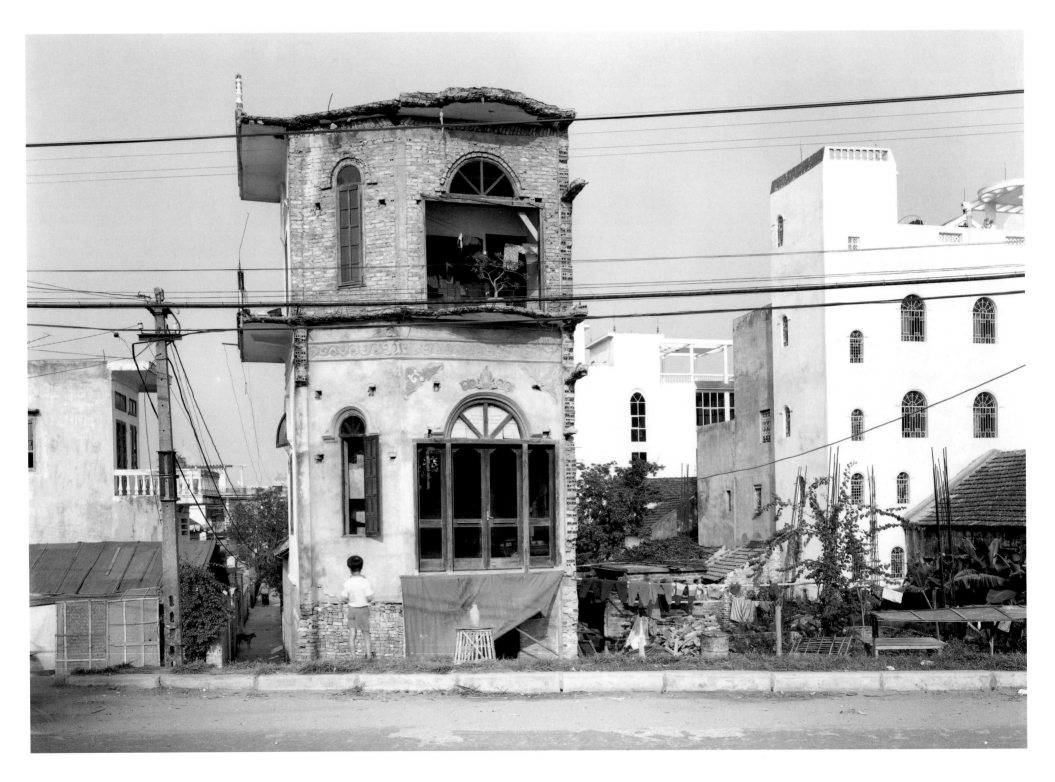

28 *Untitled, Hanoi, 1996*

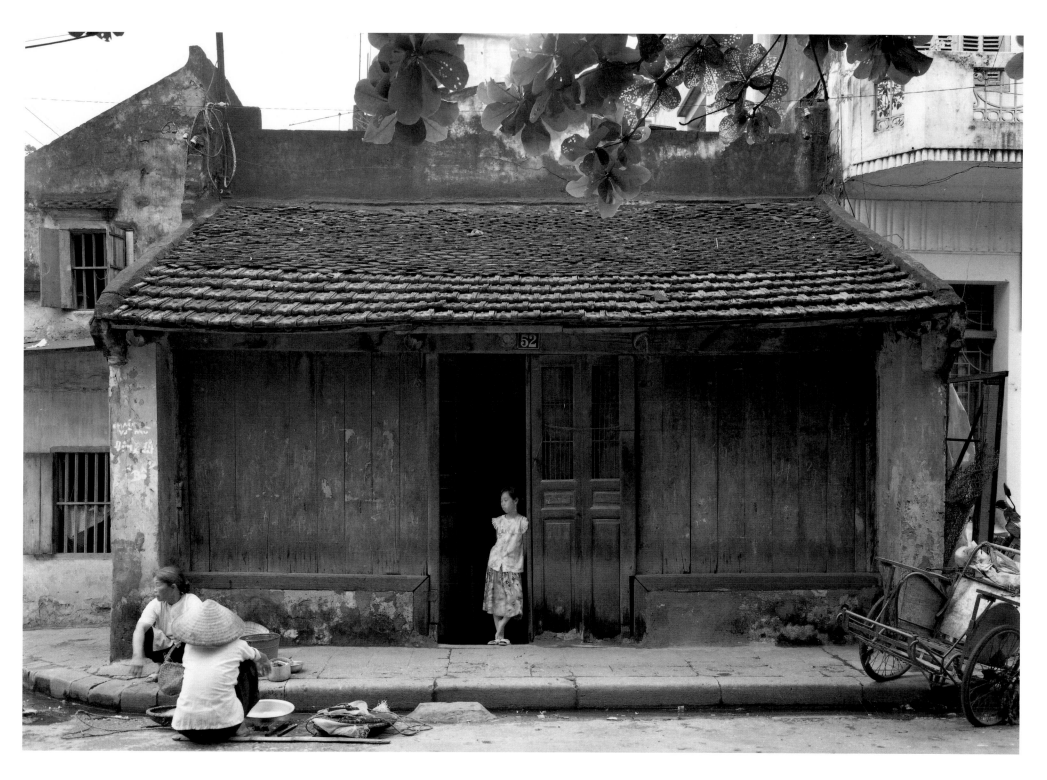

Untitled, Hanoi, 1994

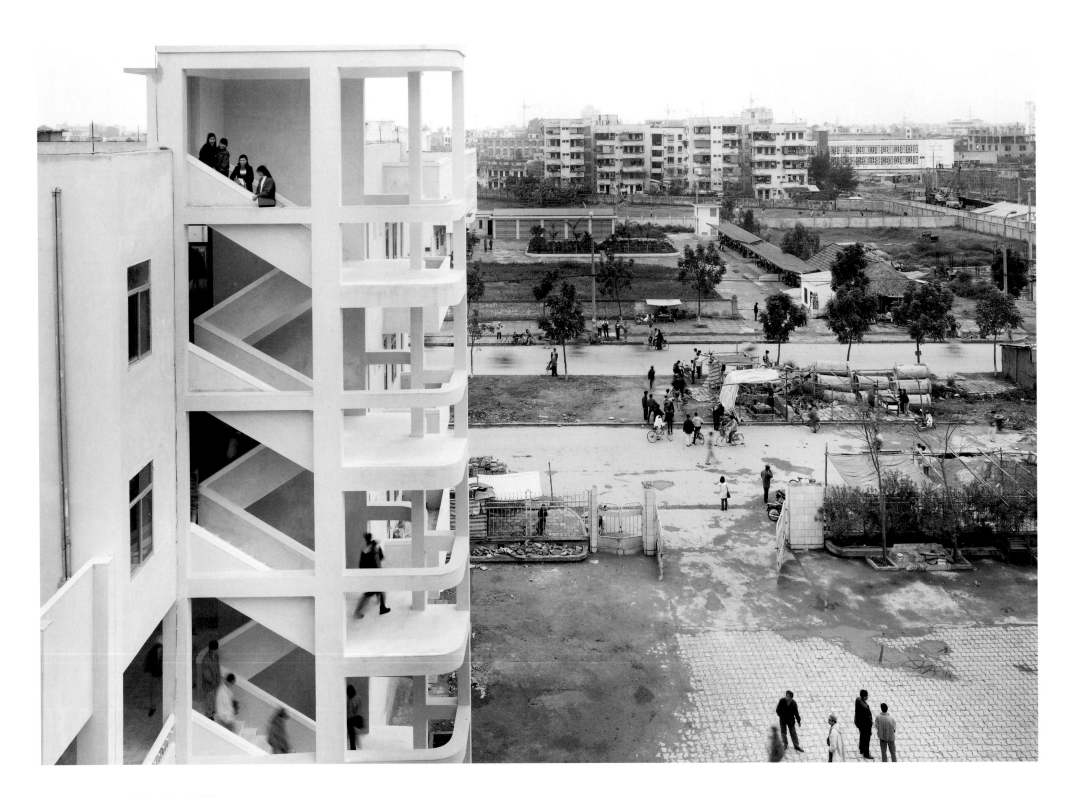

30 *Untitled, Hanoi, 1998*

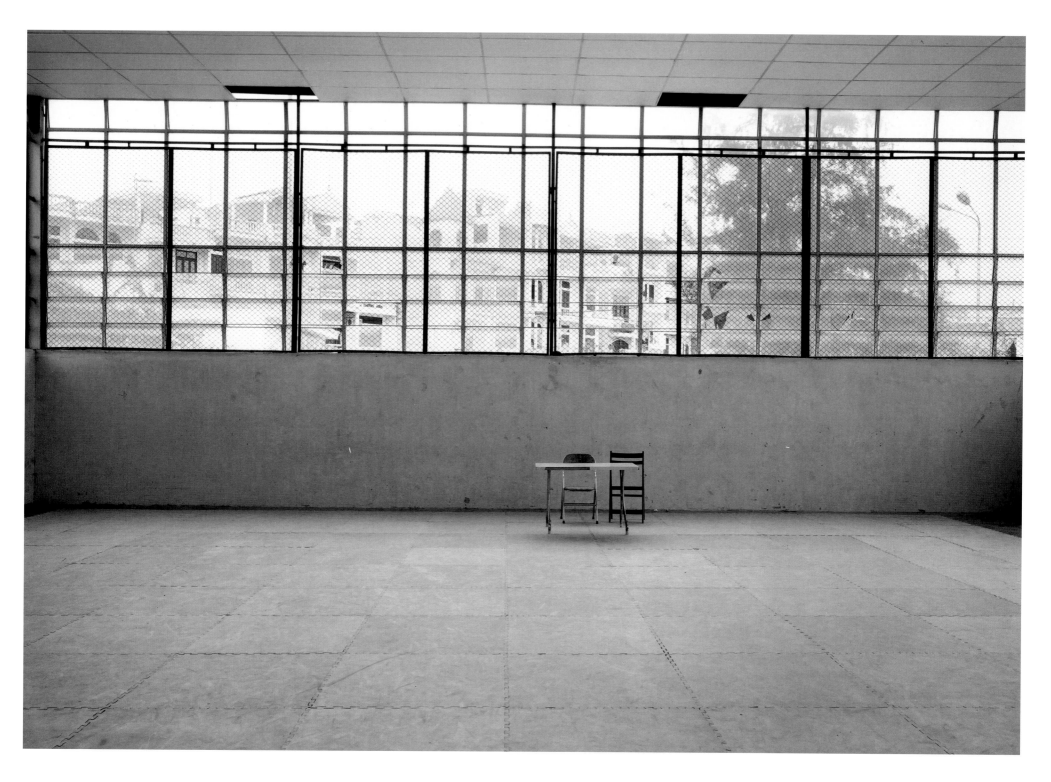

31 *Untitled, Hanoi, 1998*

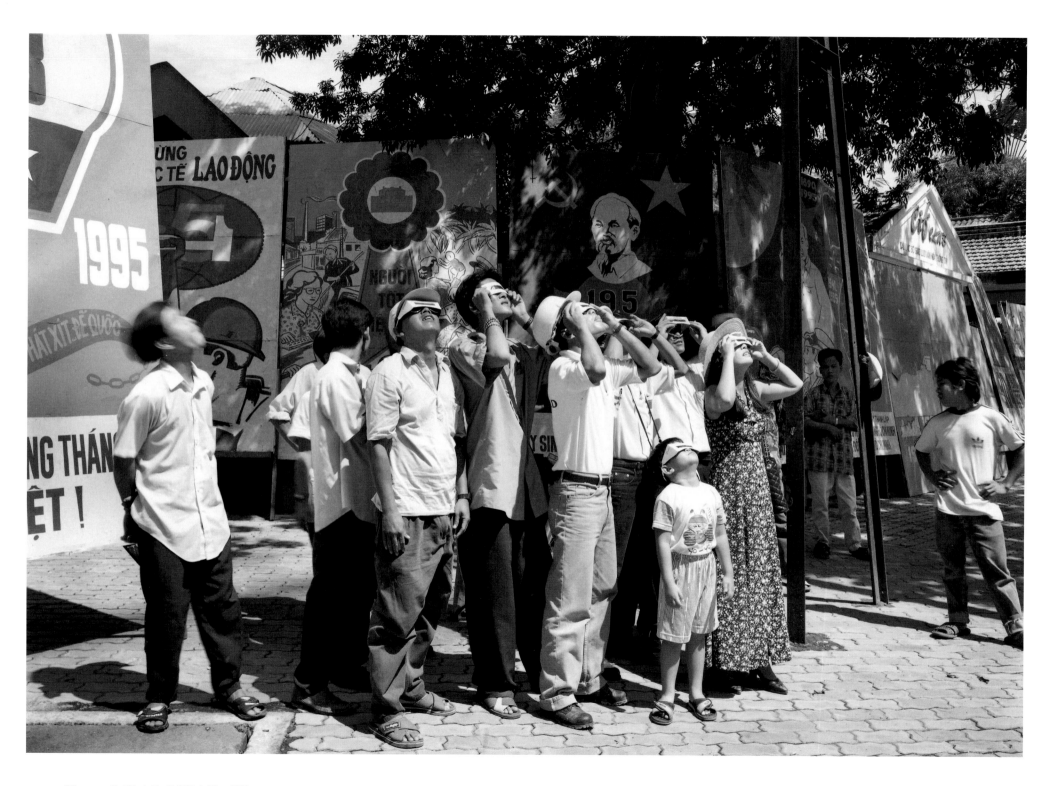

33 *Untitled, Ho Chi Minh City, 1995*

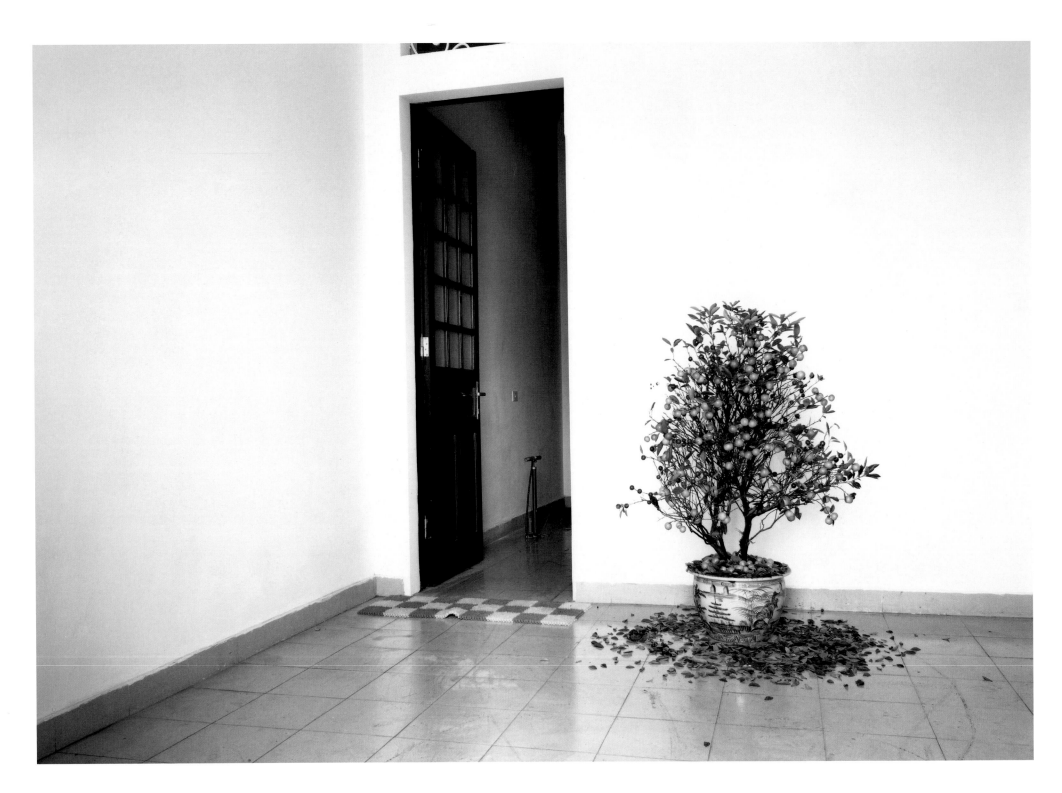

34 *Untitled, Hanoi, 1998*

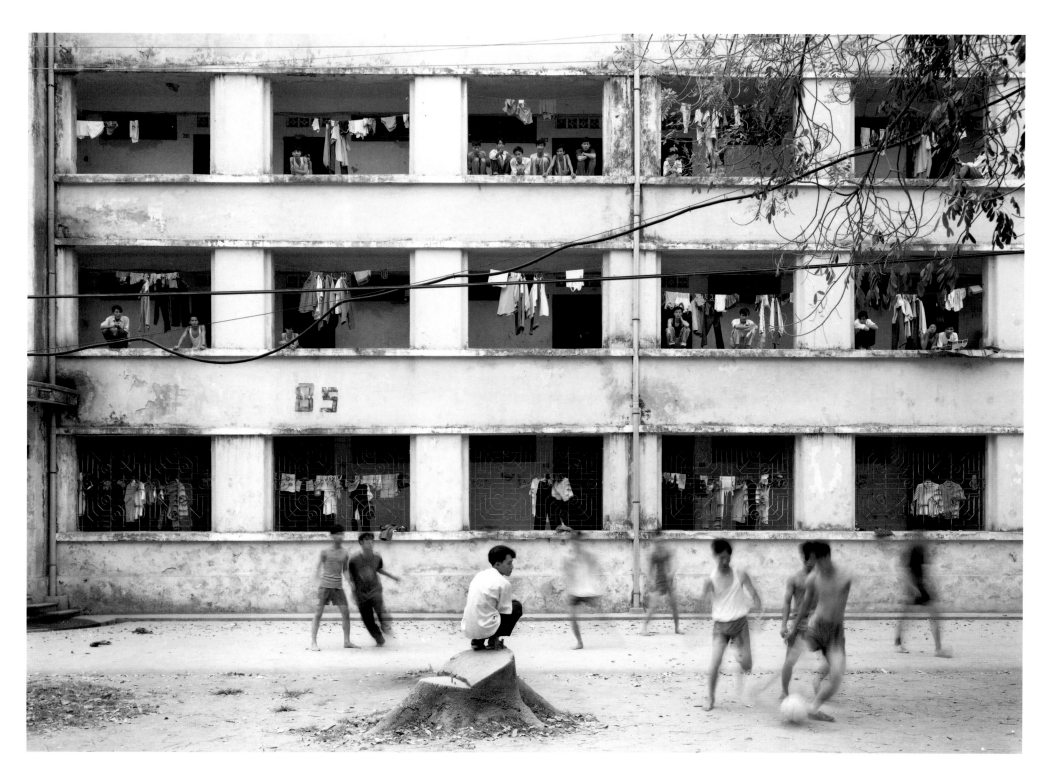

35 *Untitled, Hanoi, 1995*

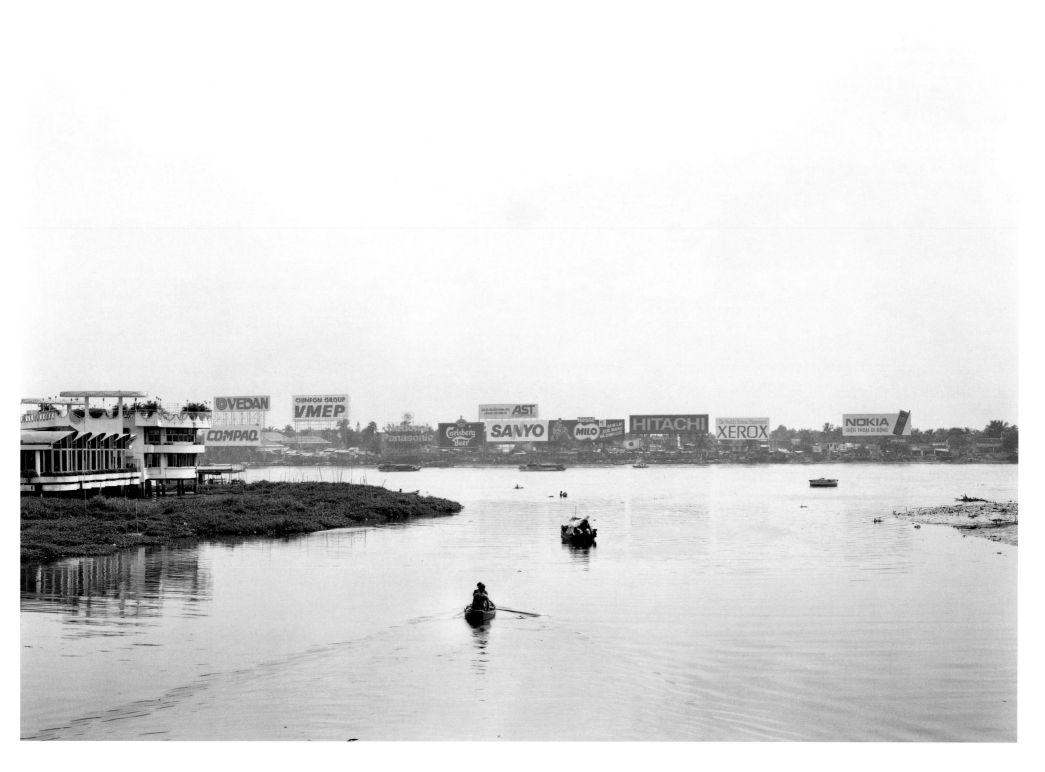

37 *Untitled, Ho Chi Minh City, 1995*

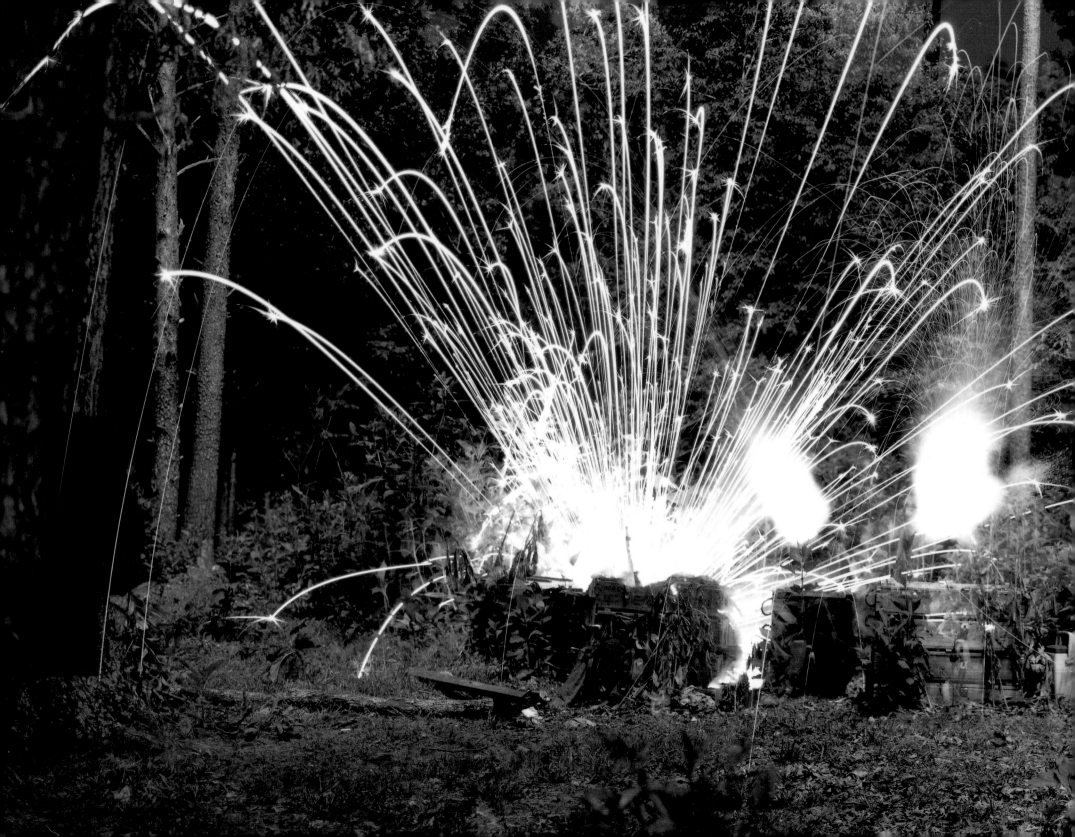

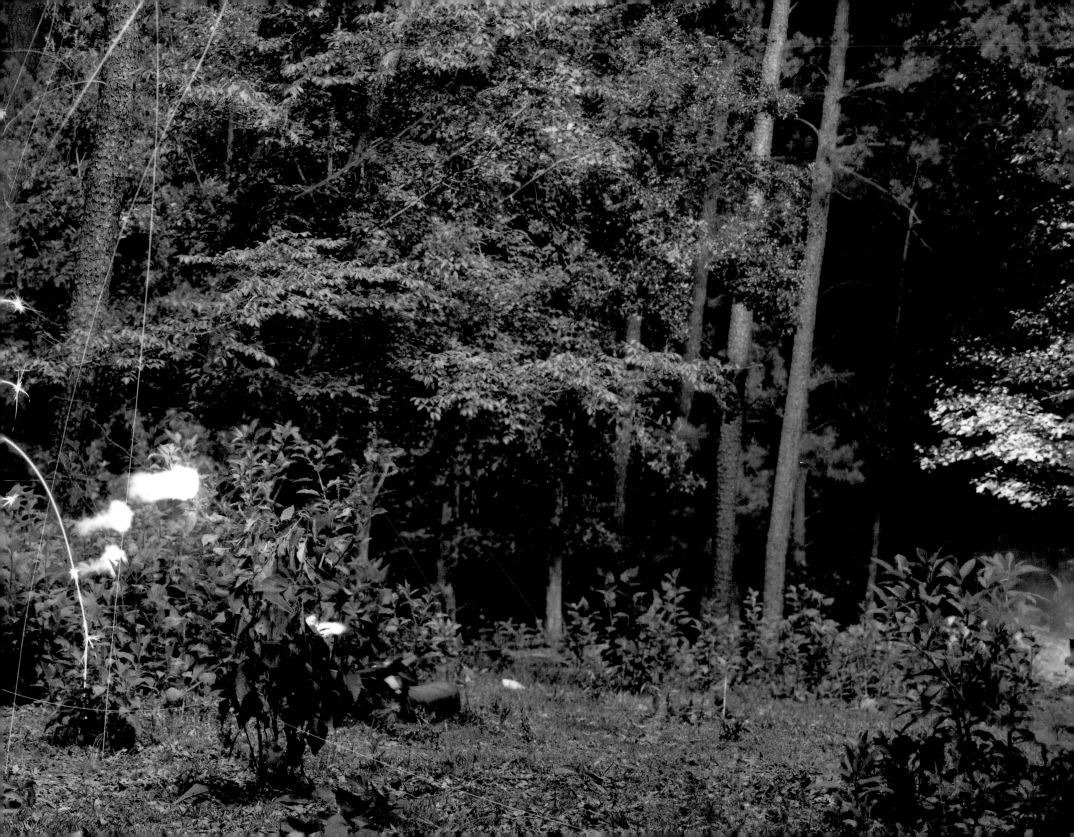

SMALL WARS

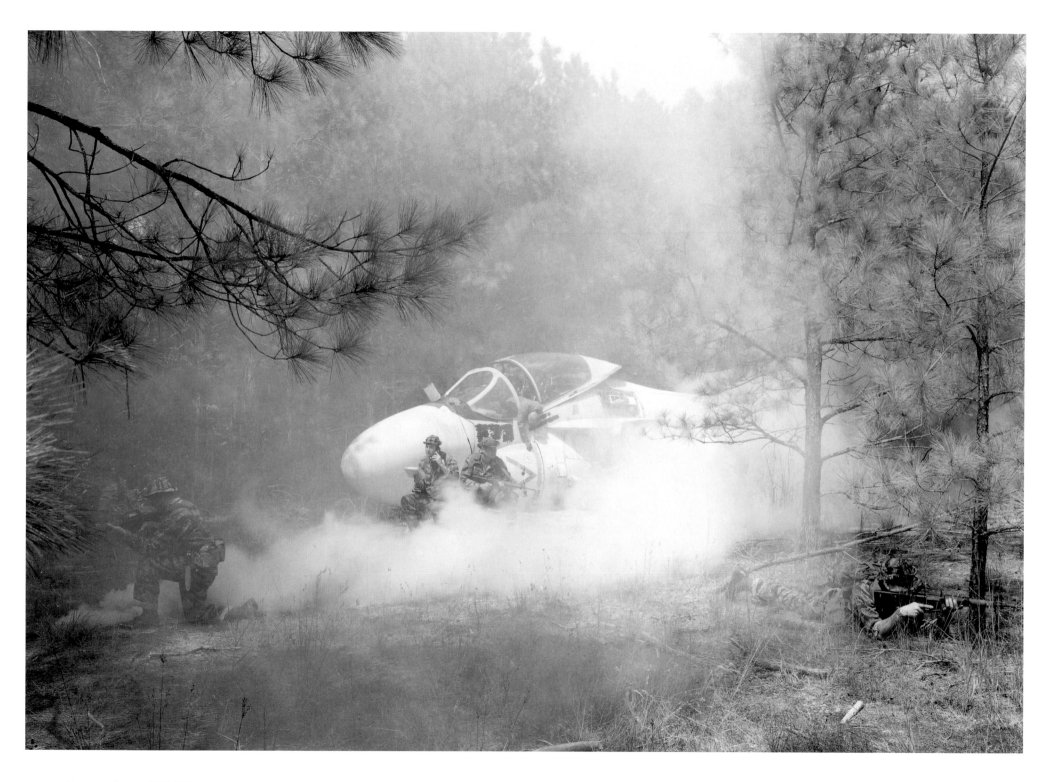

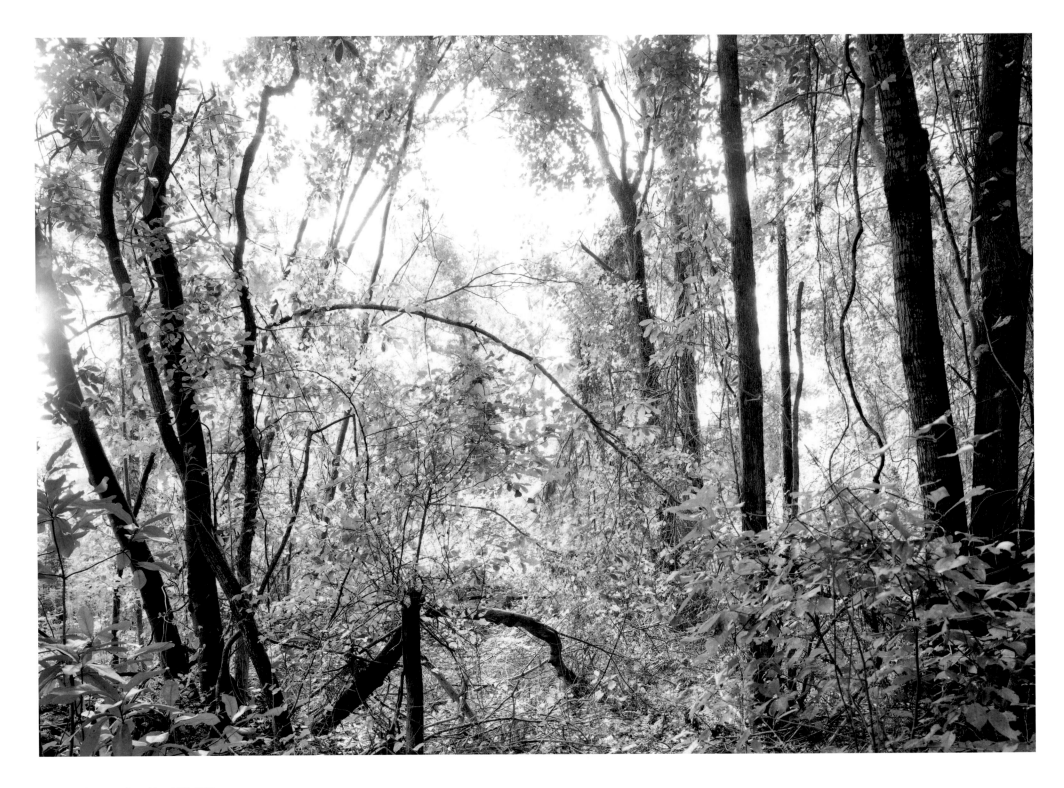

Brambles, 1999–2002

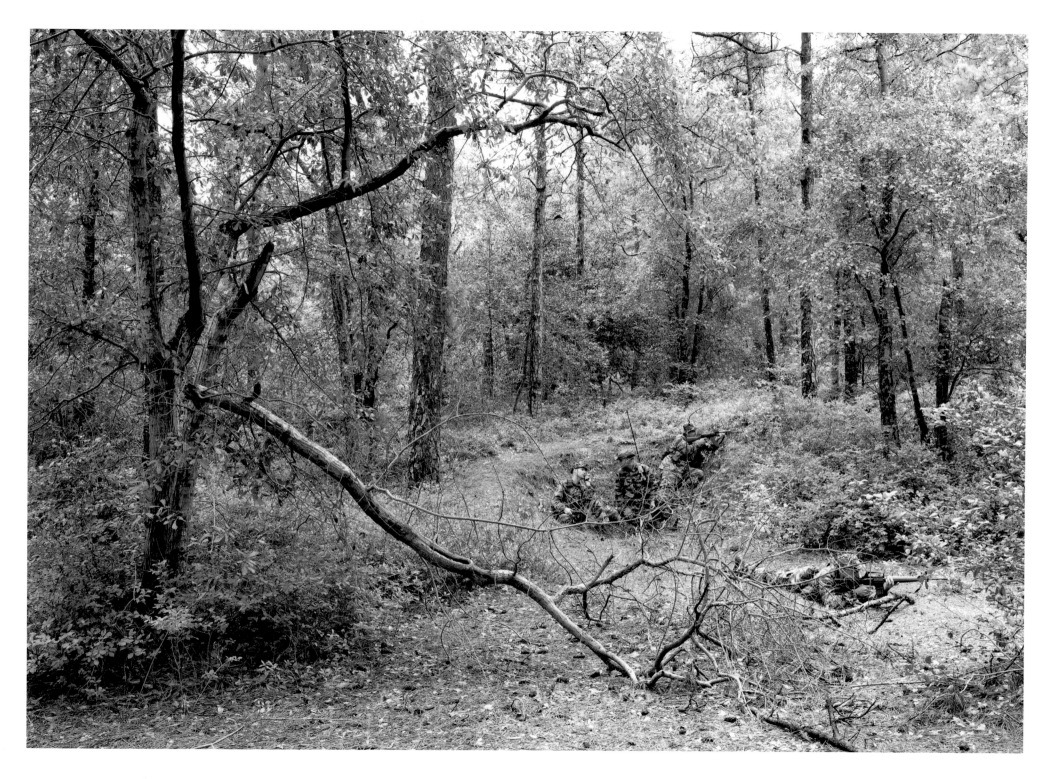

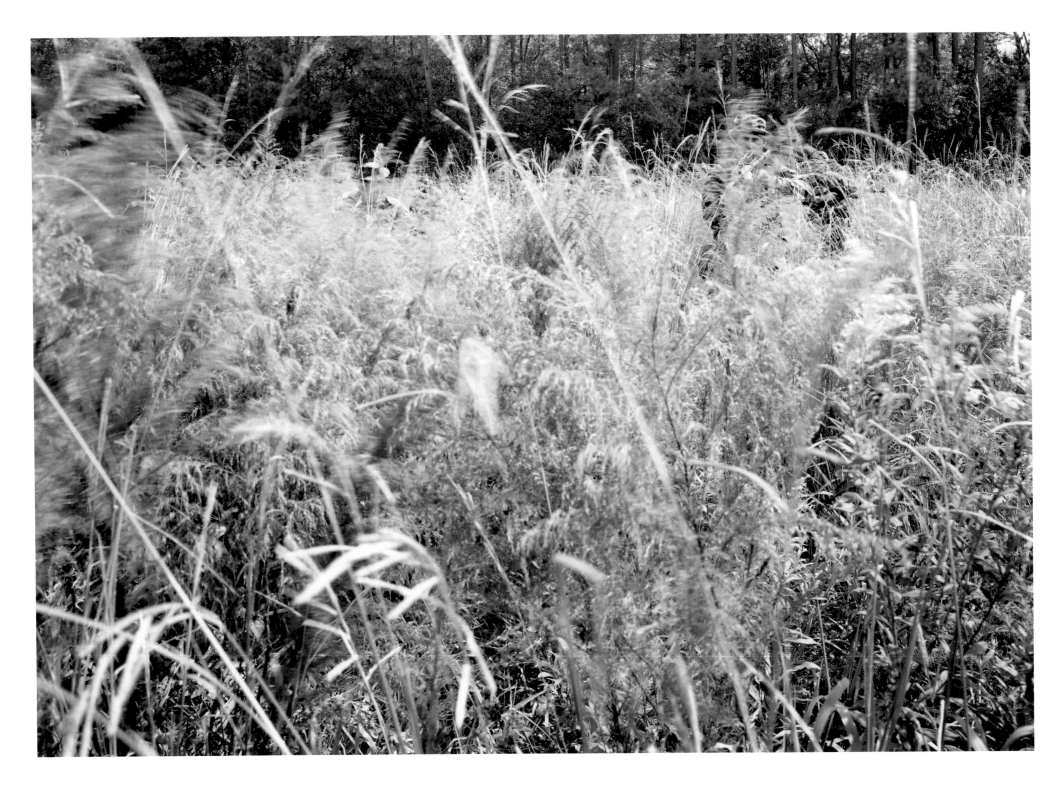

Tall Grass II, 1999–2002

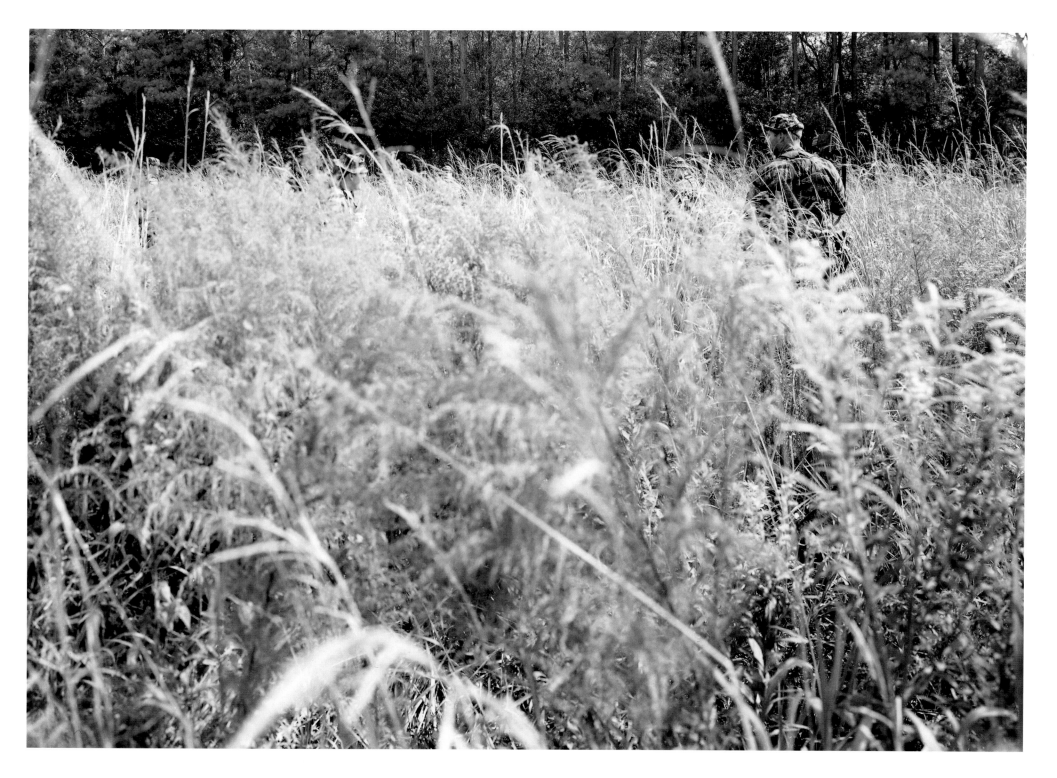

Tall Grass I, 1999–2002

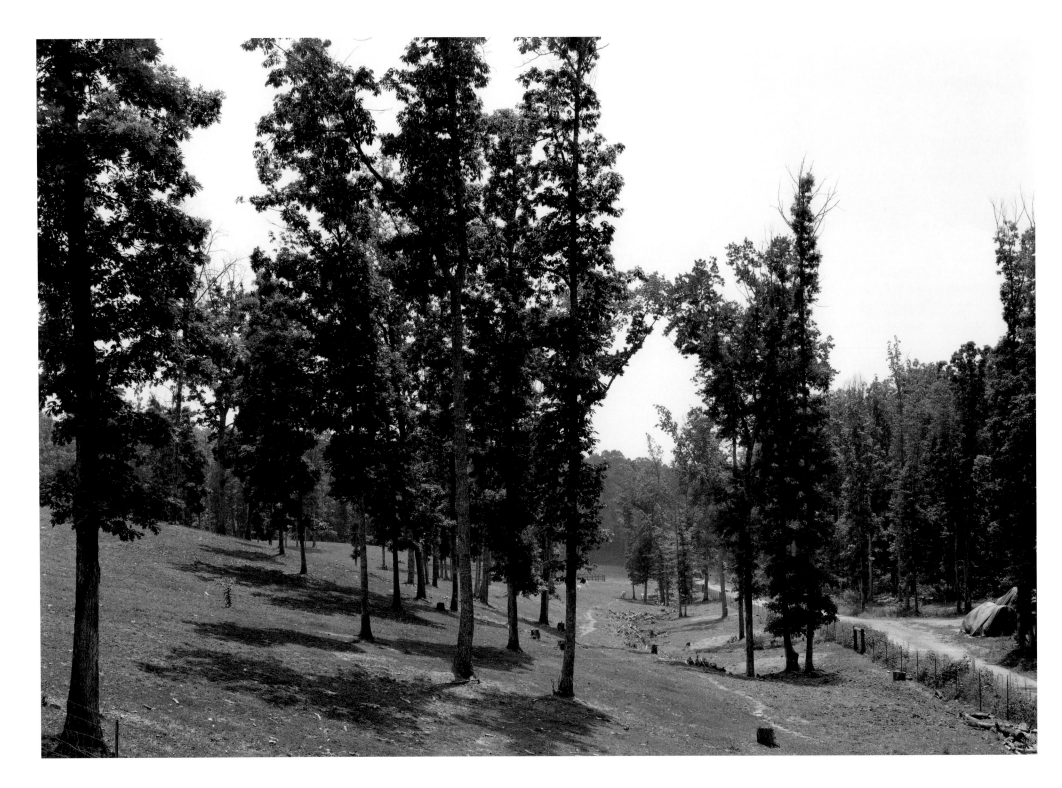

Path, 1999–2002

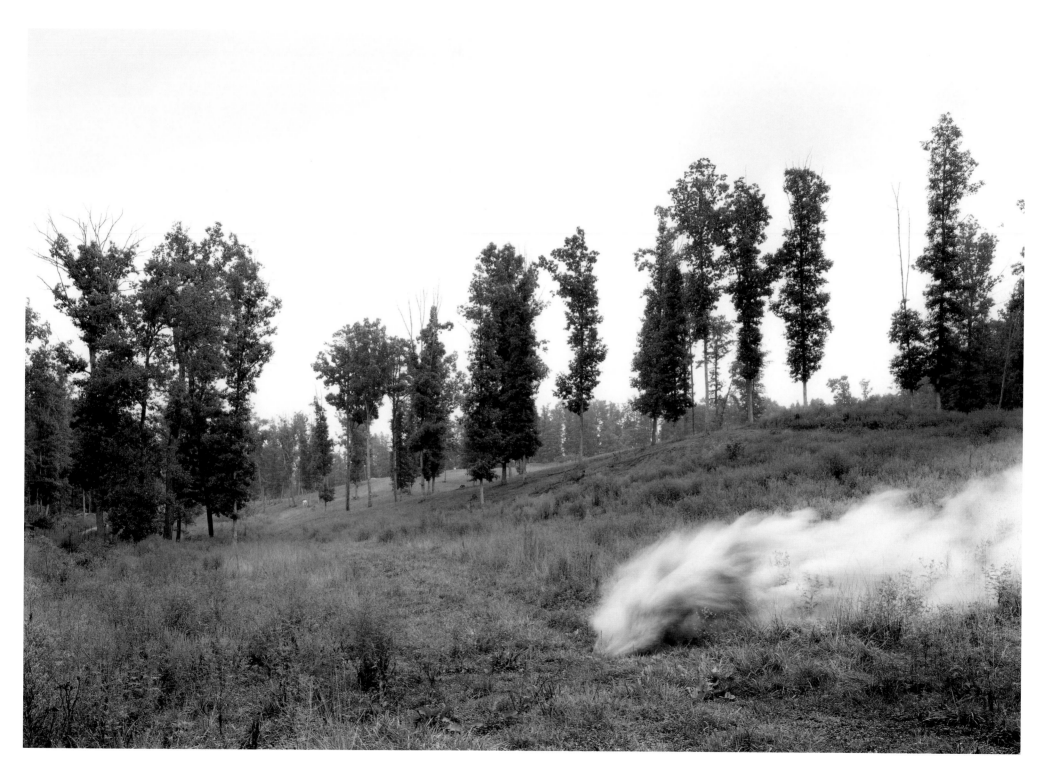

Landing Zone, 1999–2002

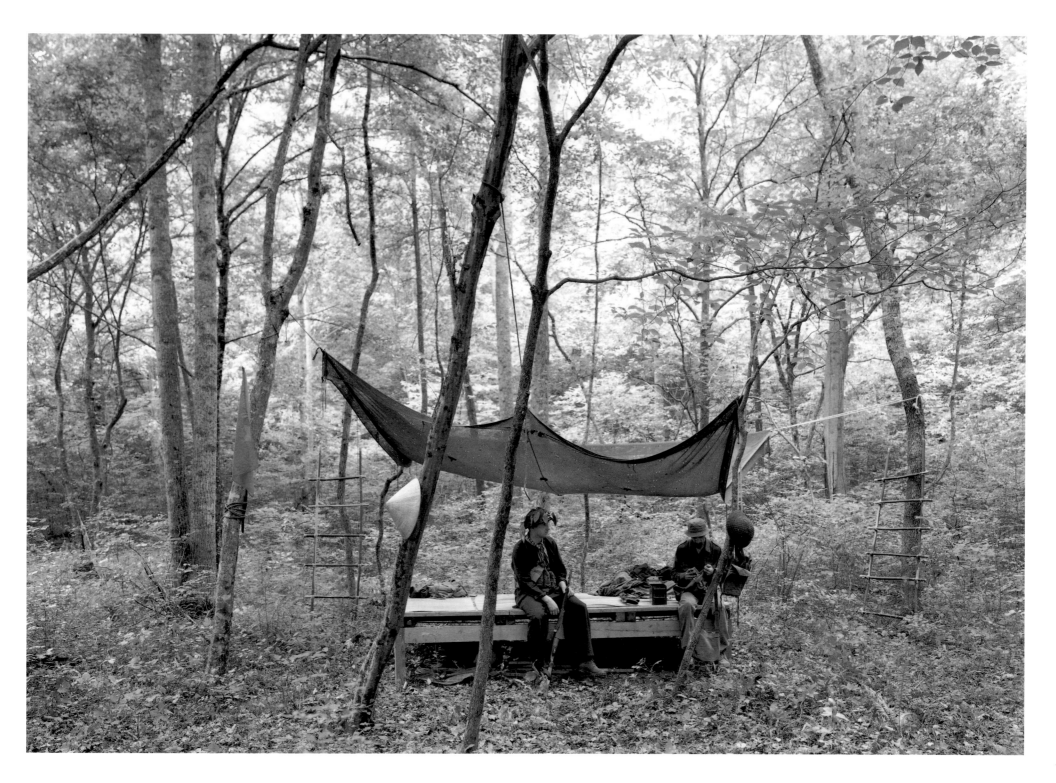

Viet Cong Camp, 1999–2002

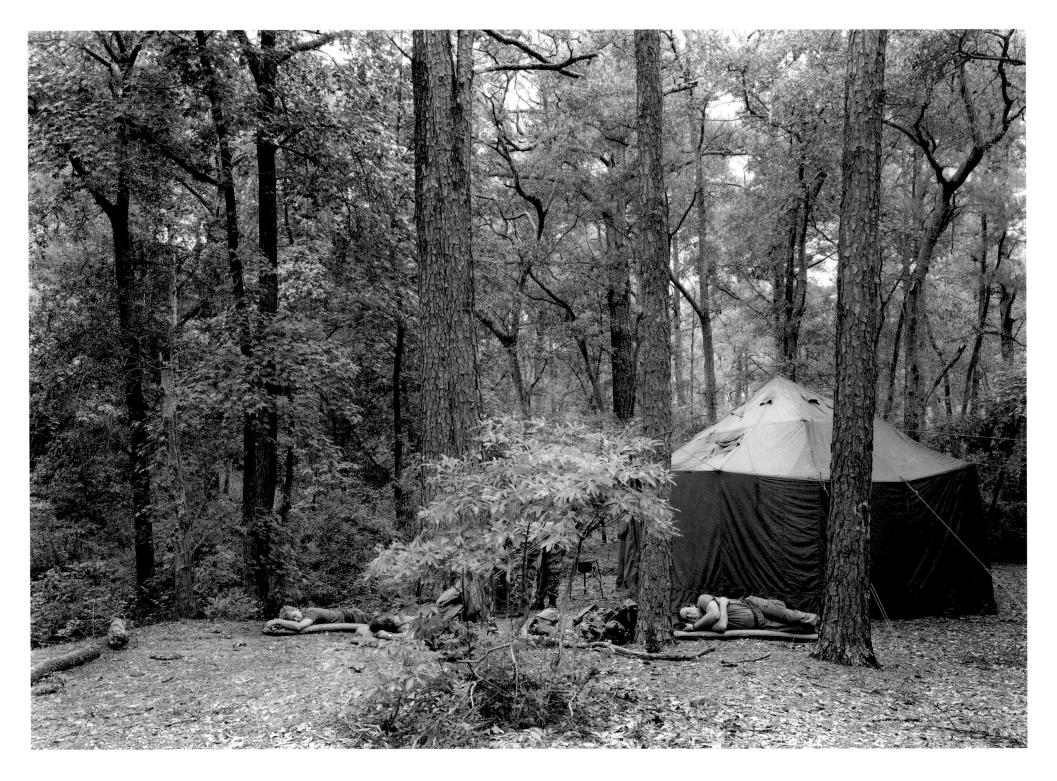

Sleeping Soldiers, 1999–2002

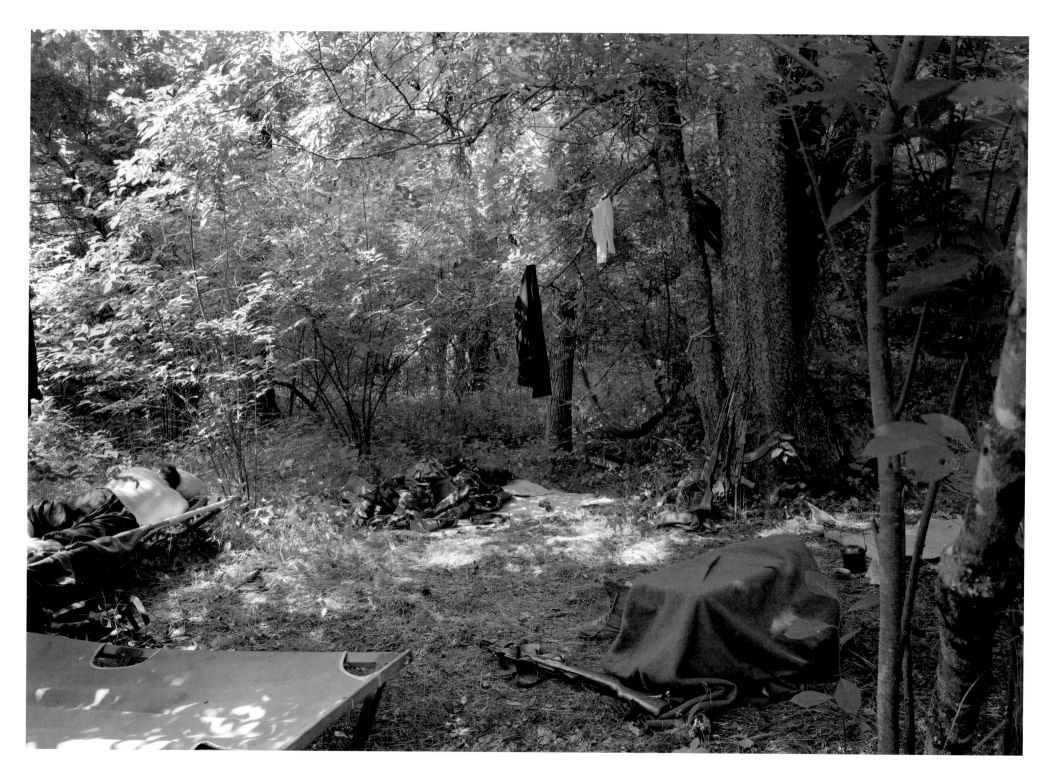

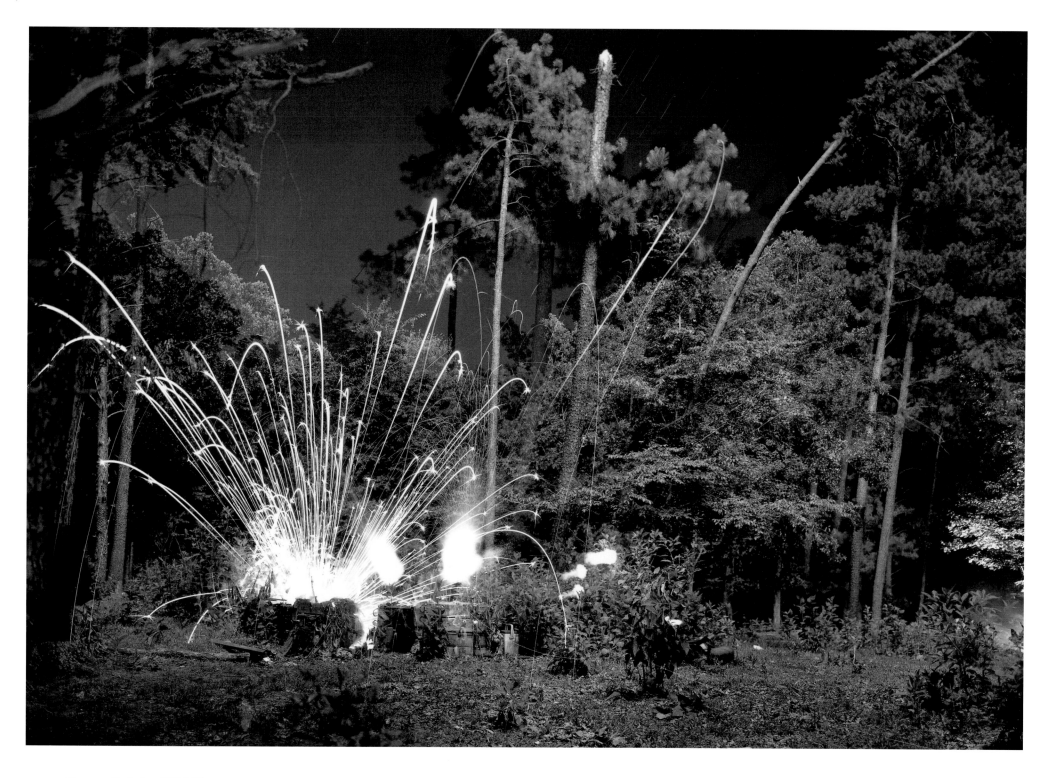

Explosion, 1999–2002

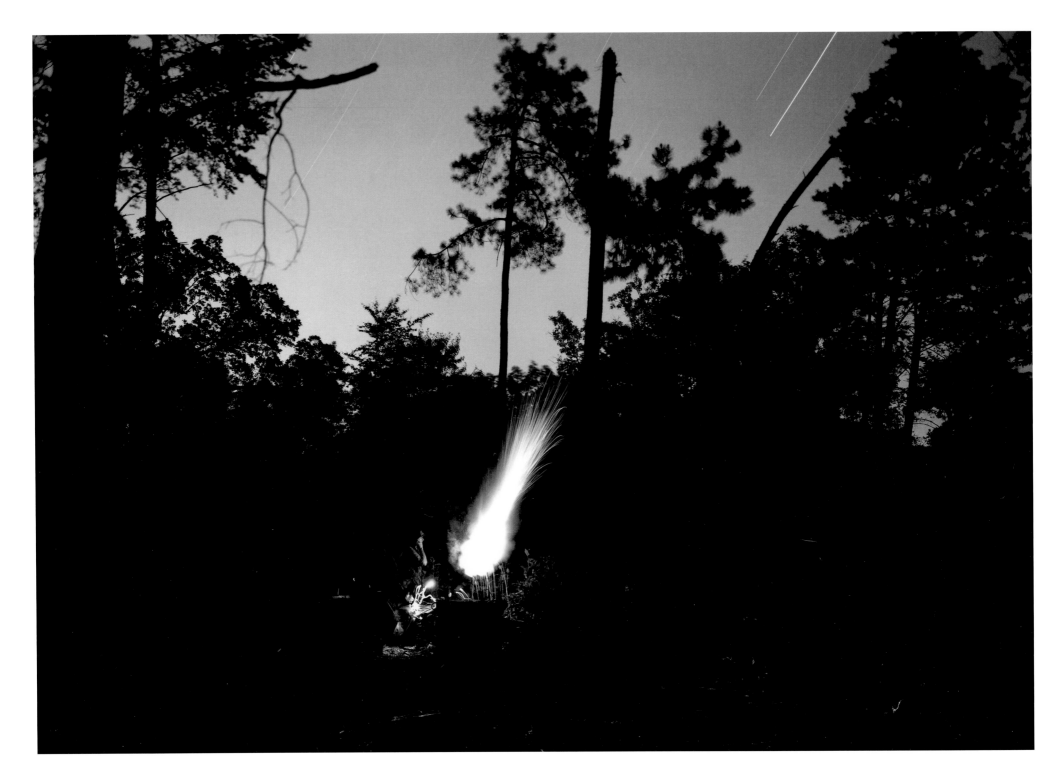

Mortar, 1999–2002

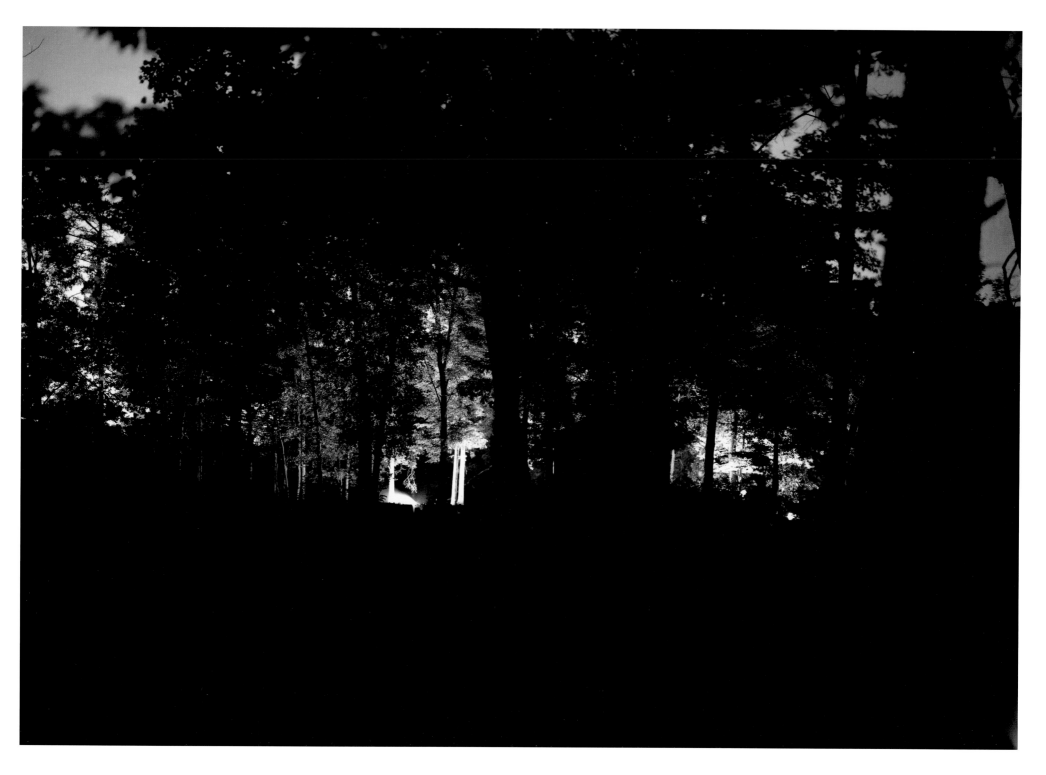

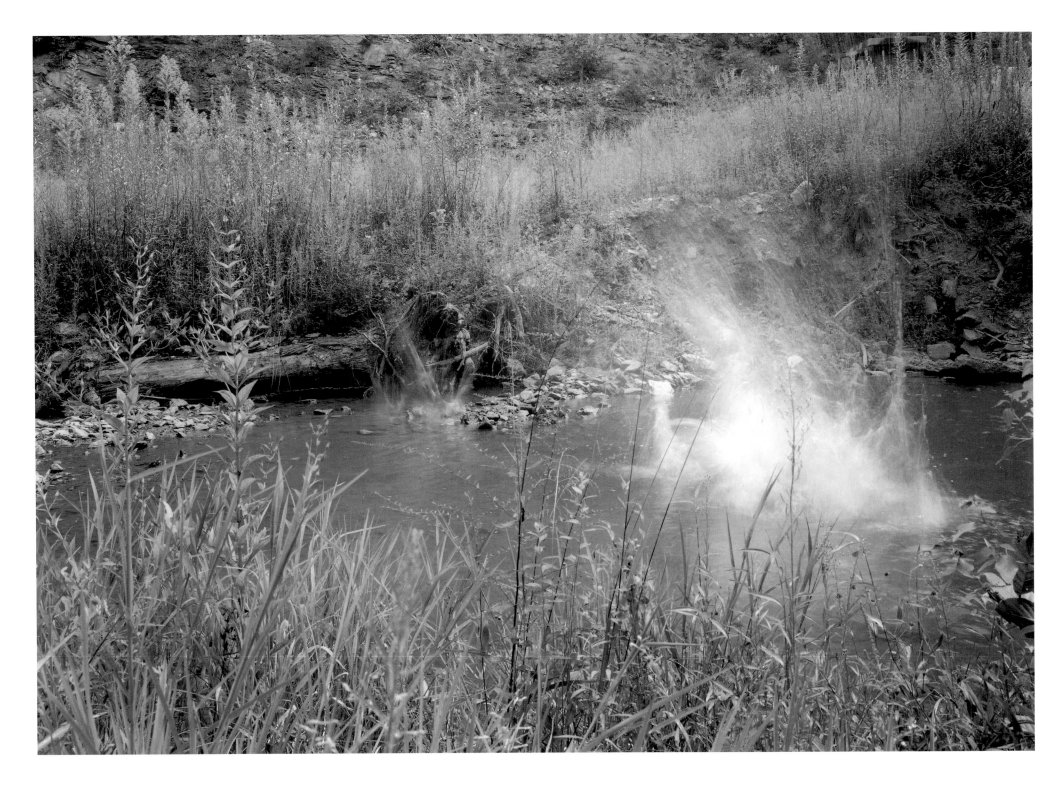

Creek, 1999–2002

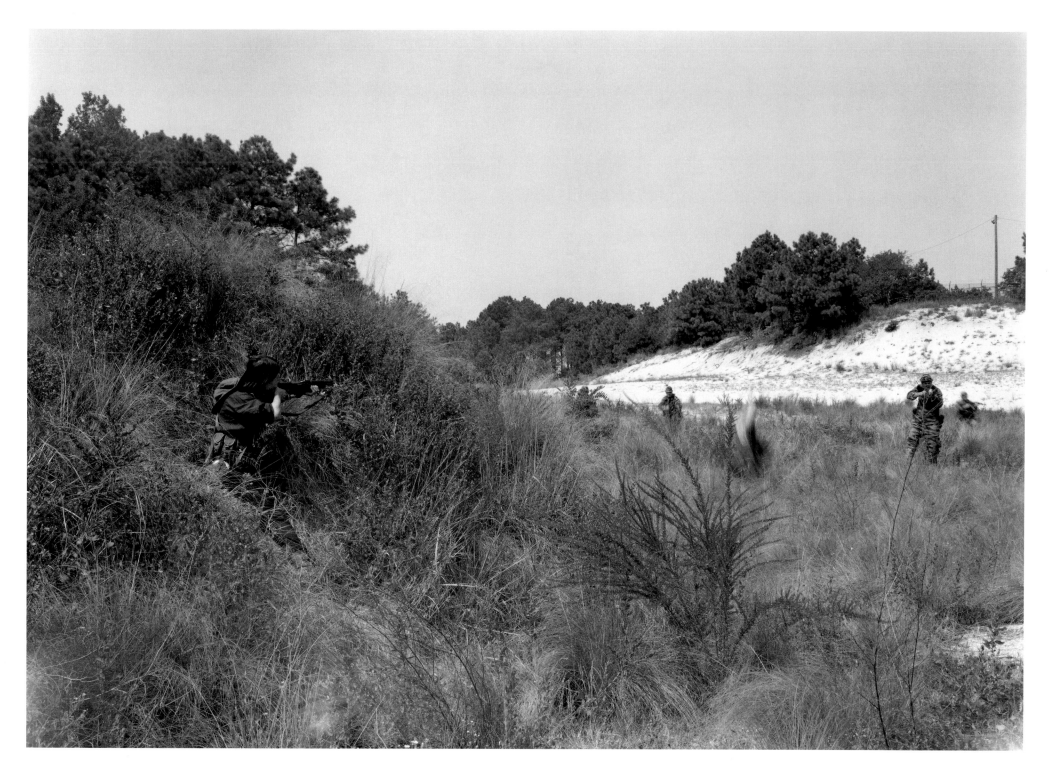

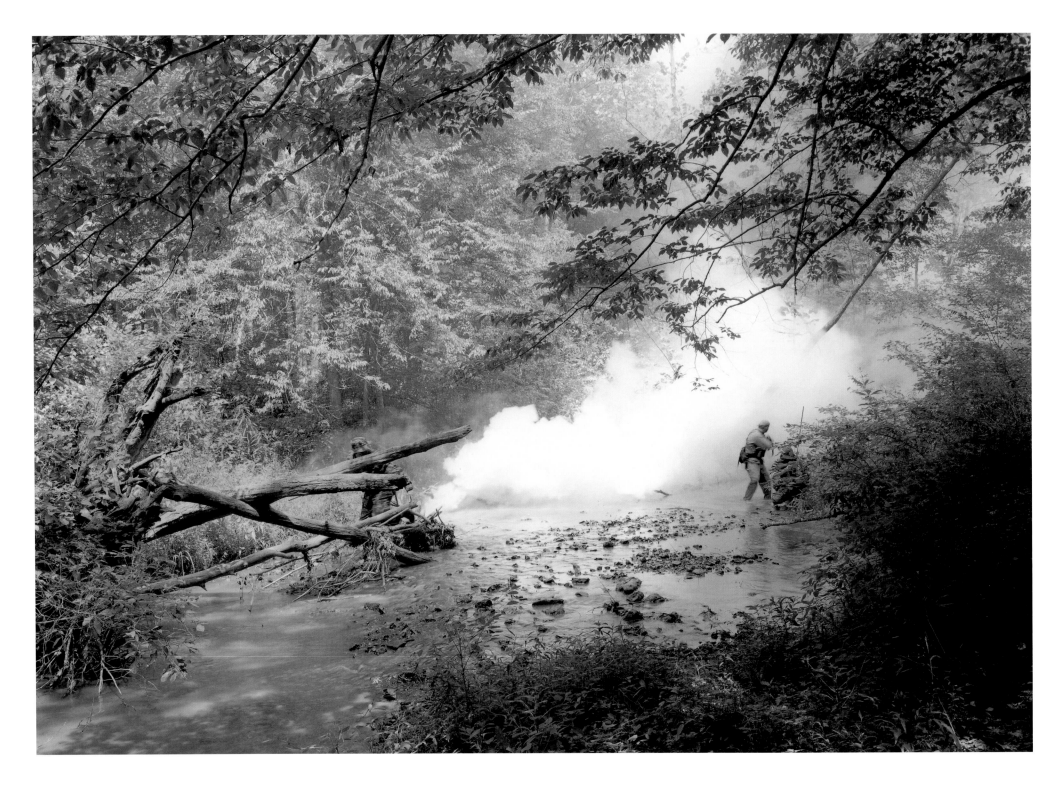

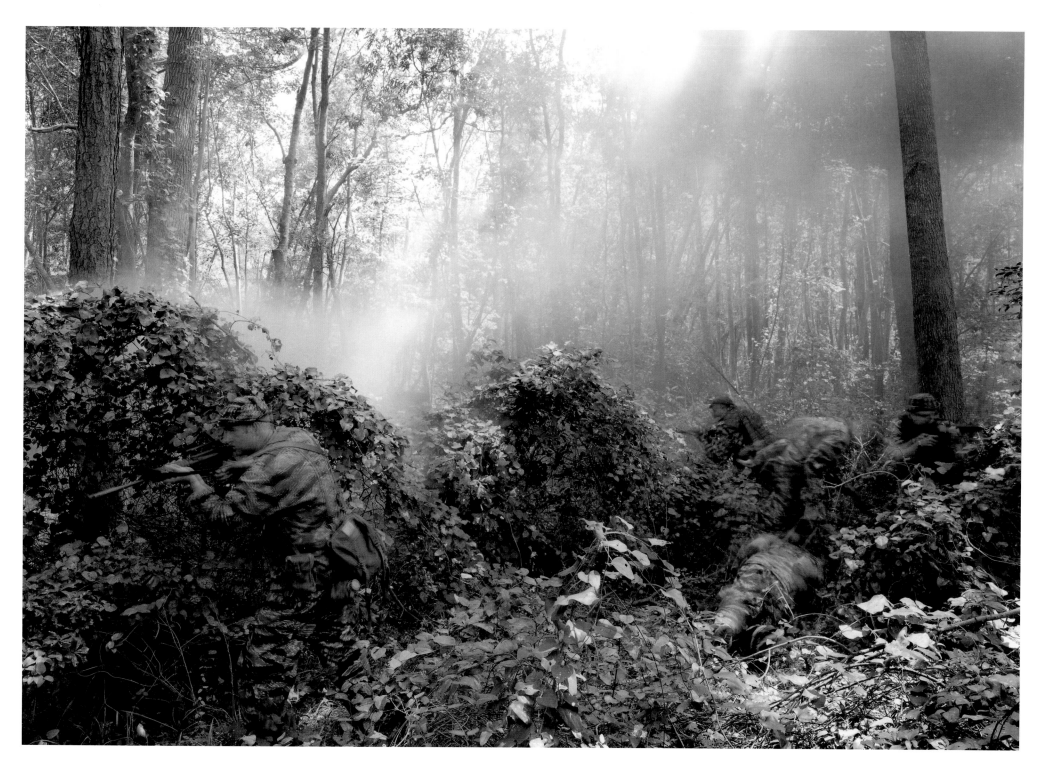

Ambush I, 1999–2002

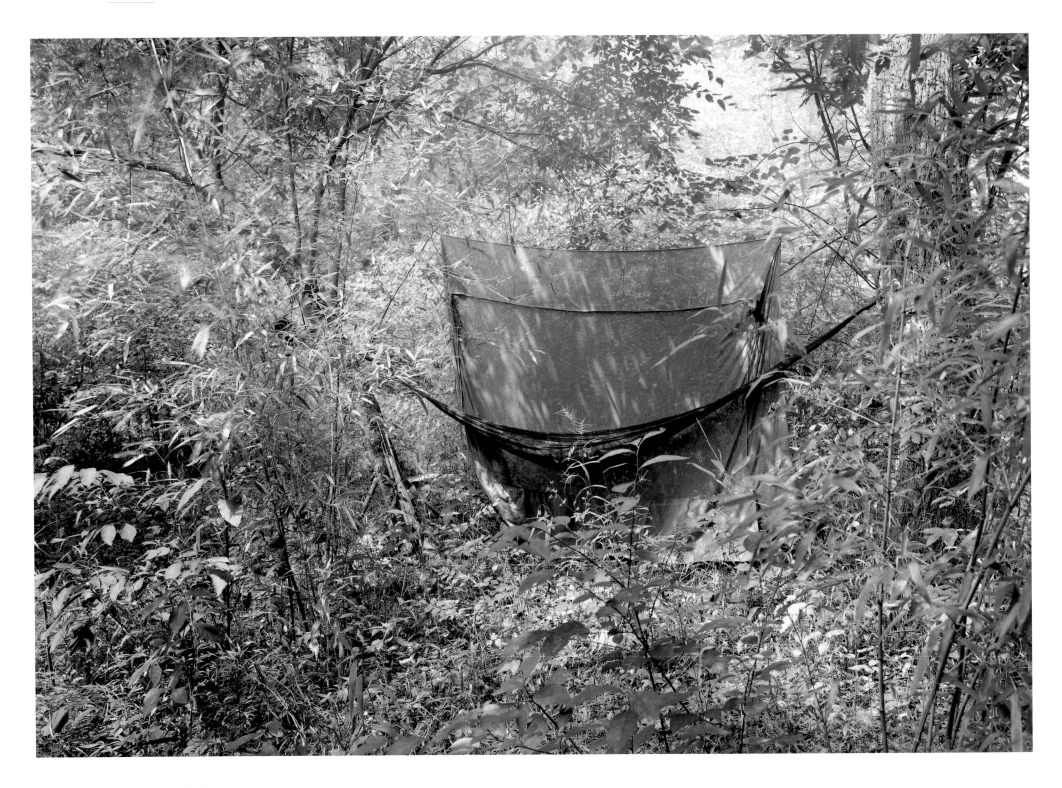

61 *Bamboo, 1999–2002*

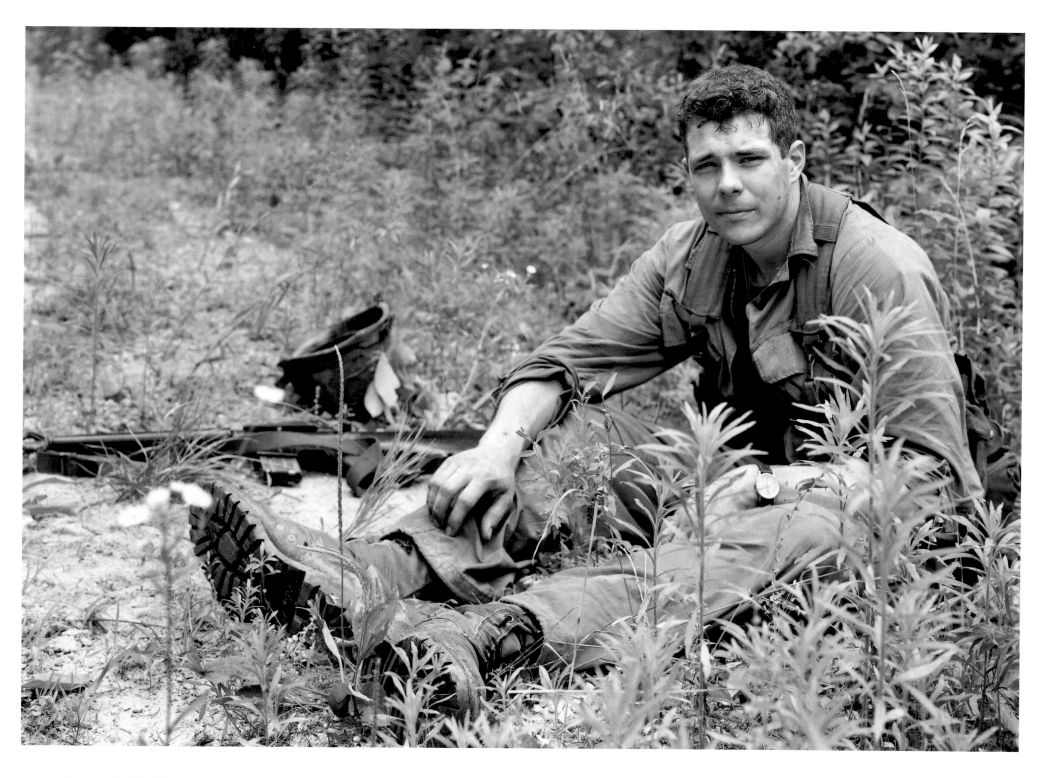

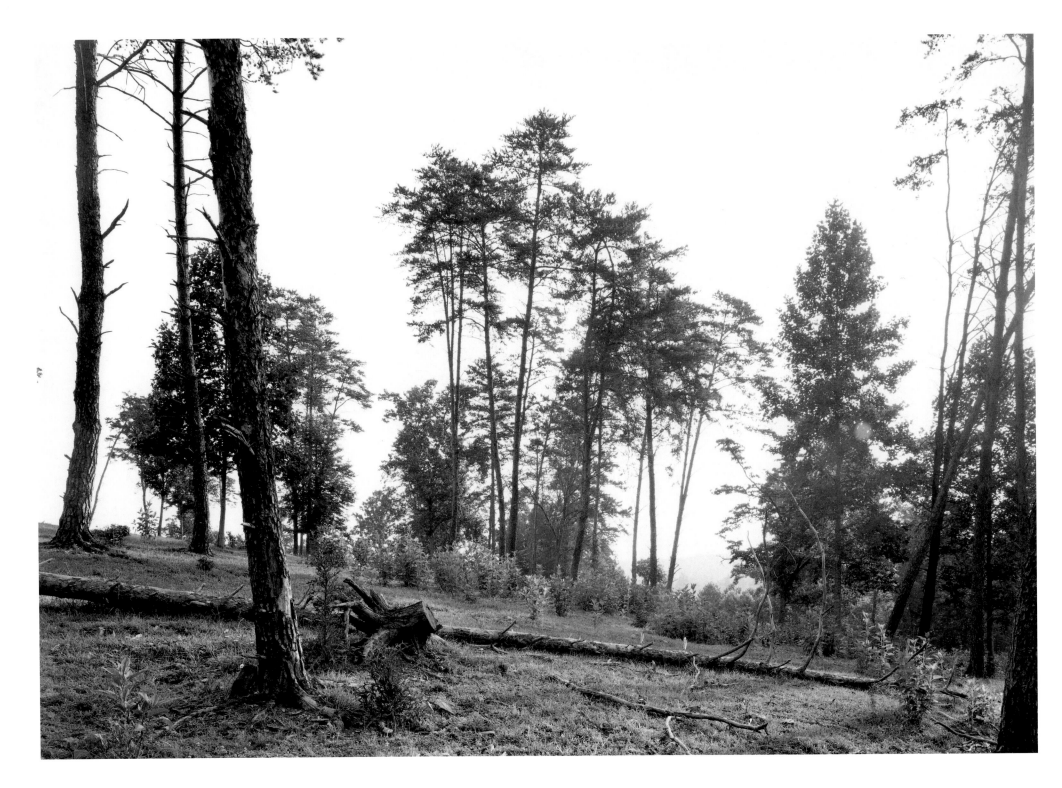

Fallen Tree, 1999–2002

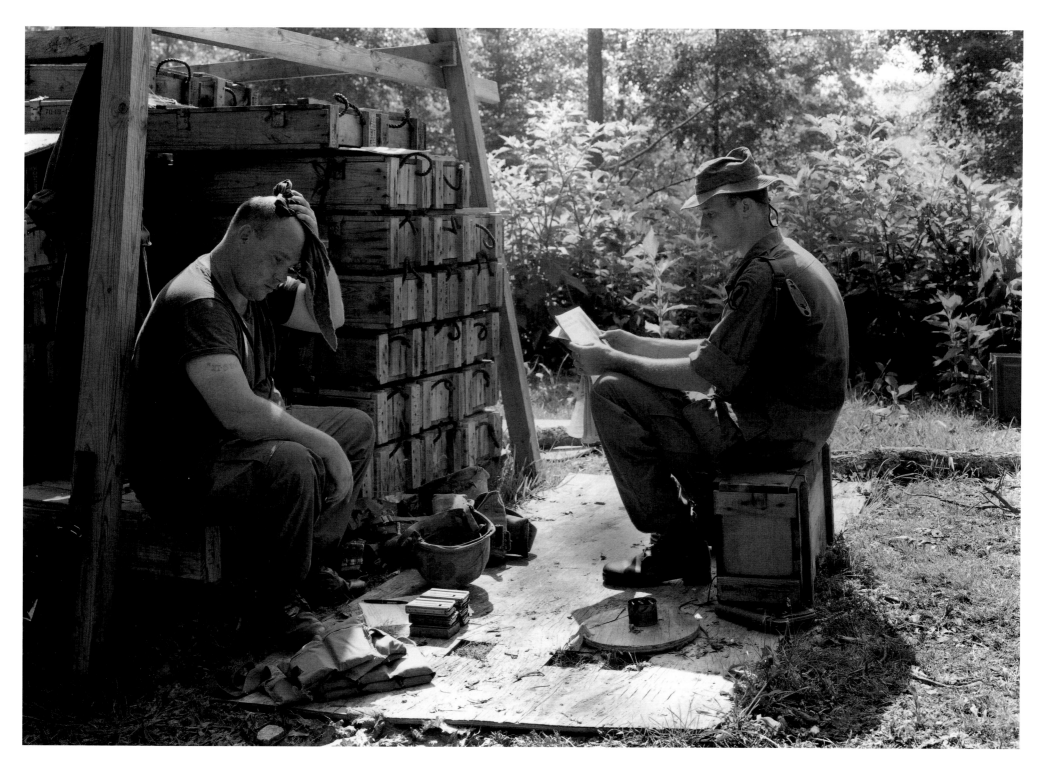

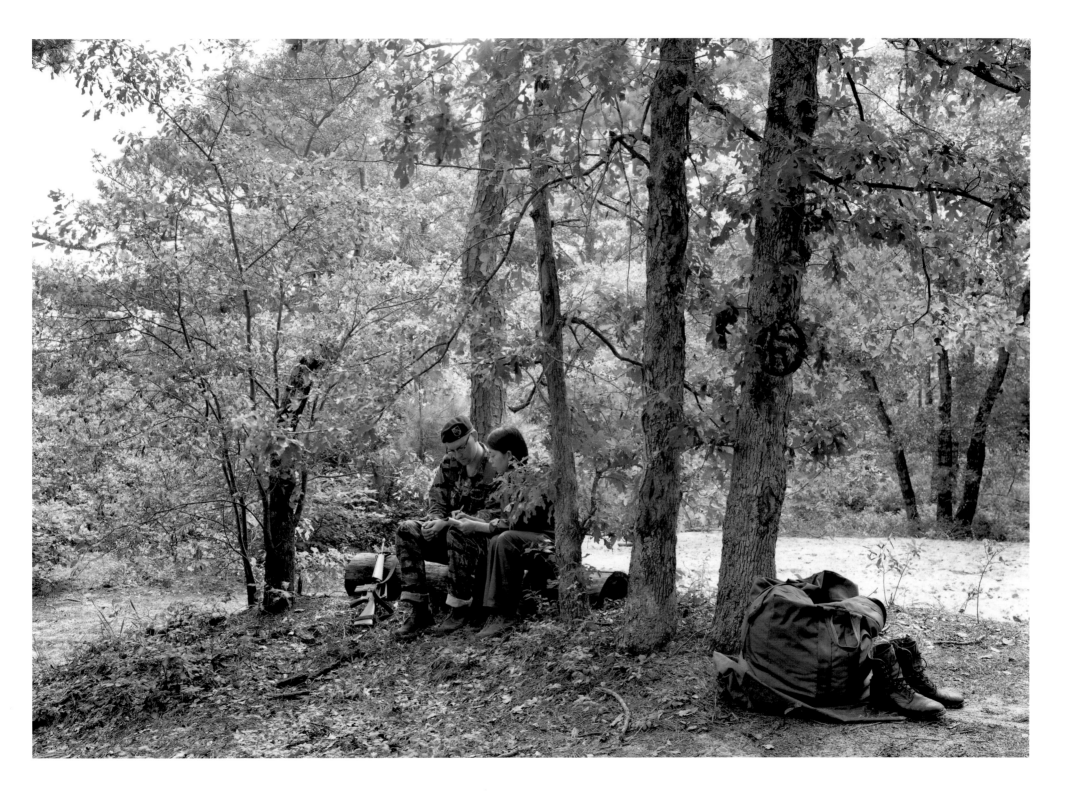

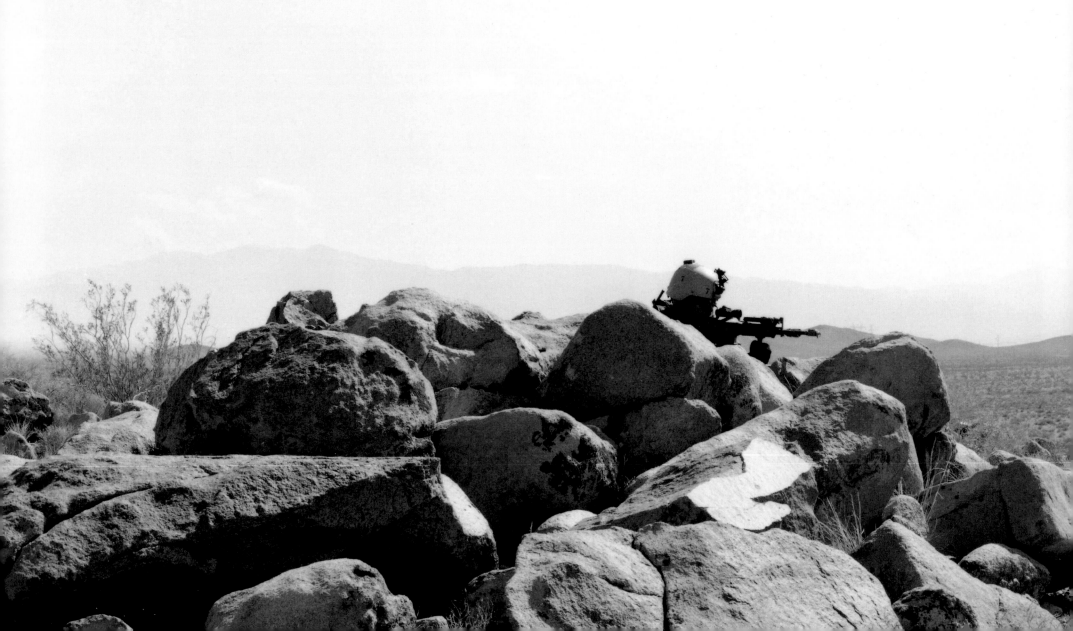

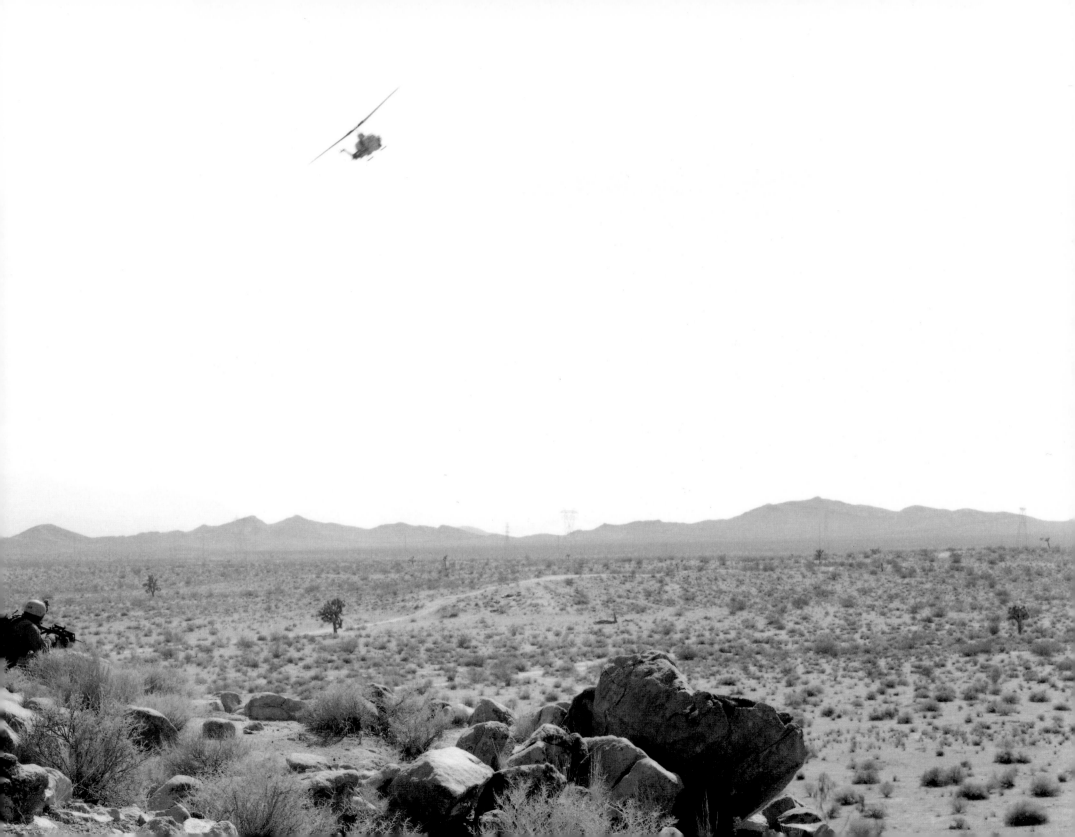

29 PALMS

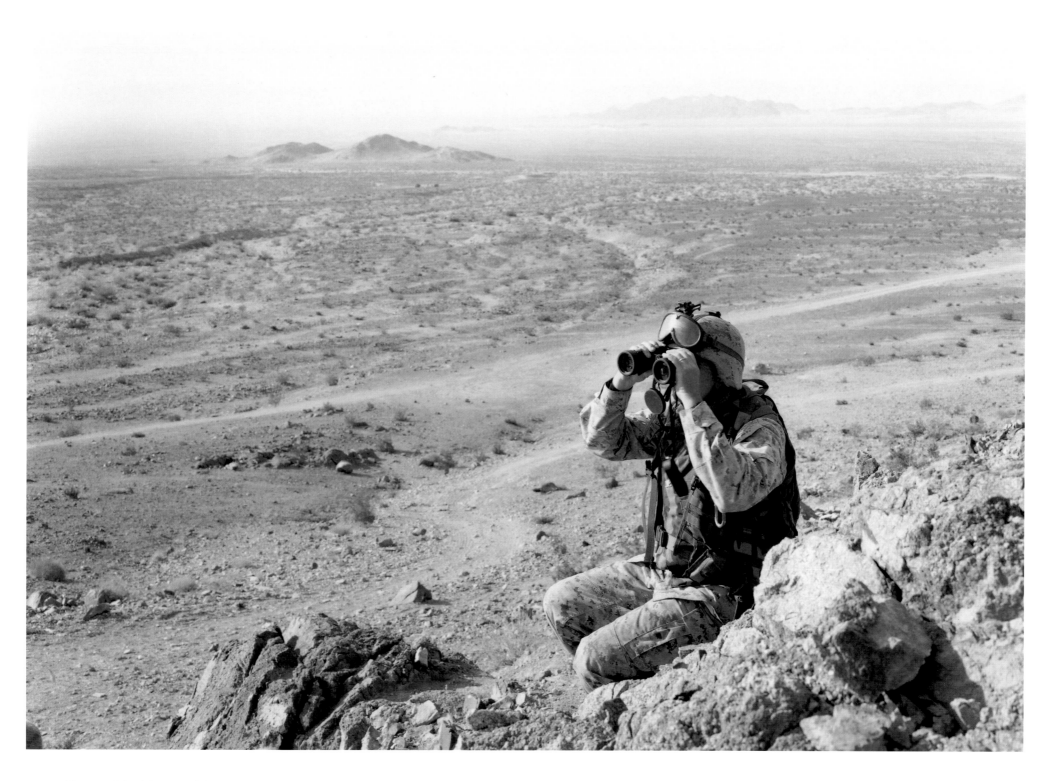

71 *Colonel Greenwood, 2003–4*

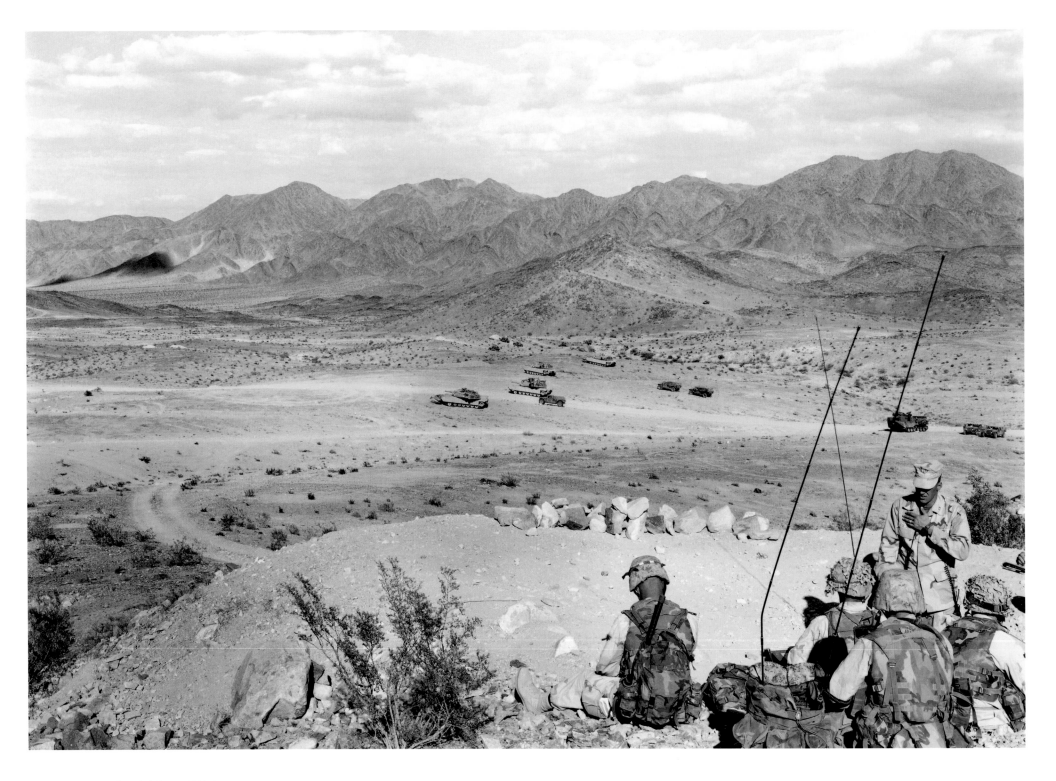

Captain Folsom, 2003–4

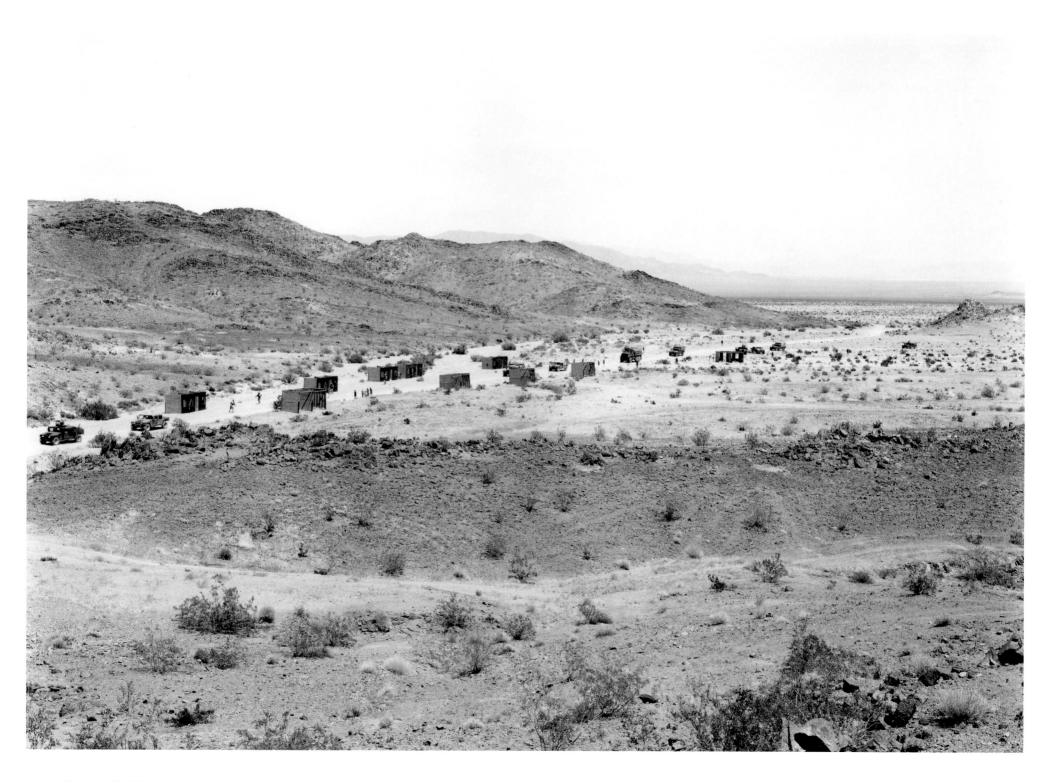

Small Convoy Attack, 2003–4

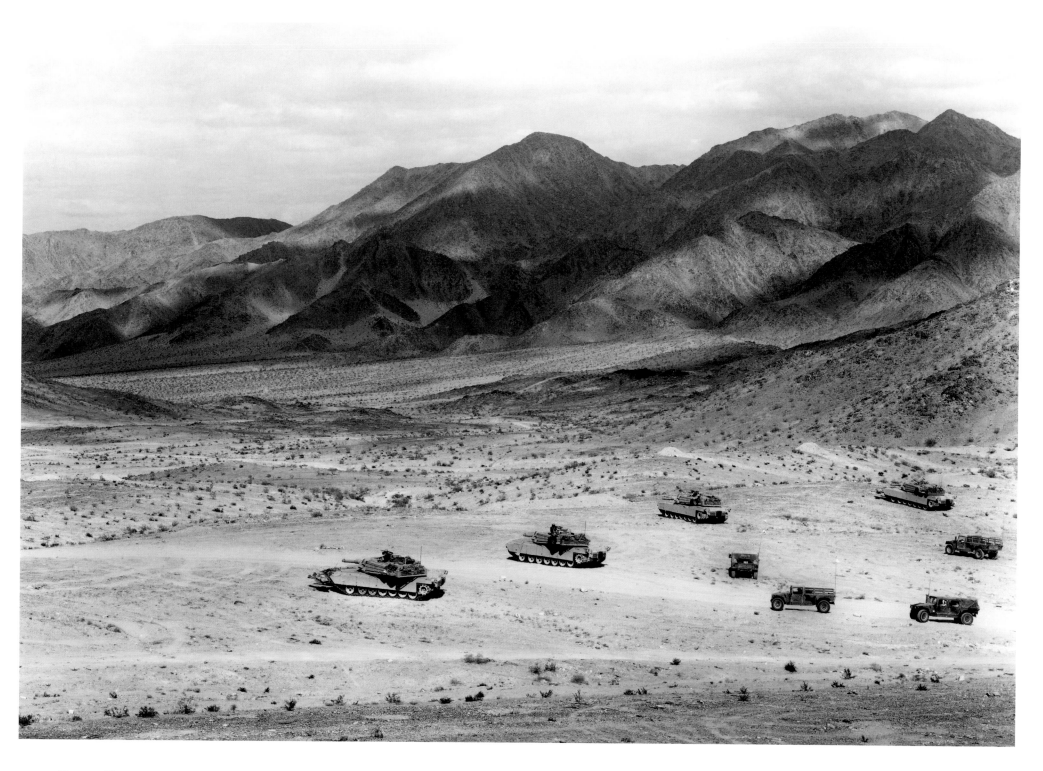

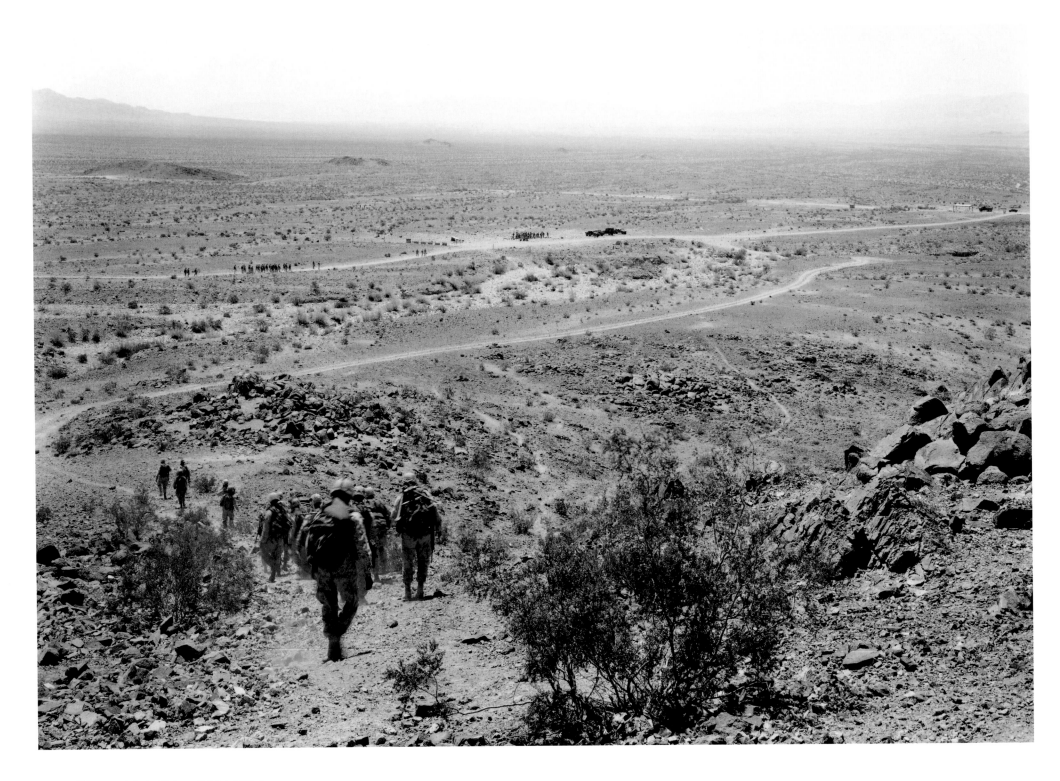

Infantry Platoon, Retreat, 2003–4

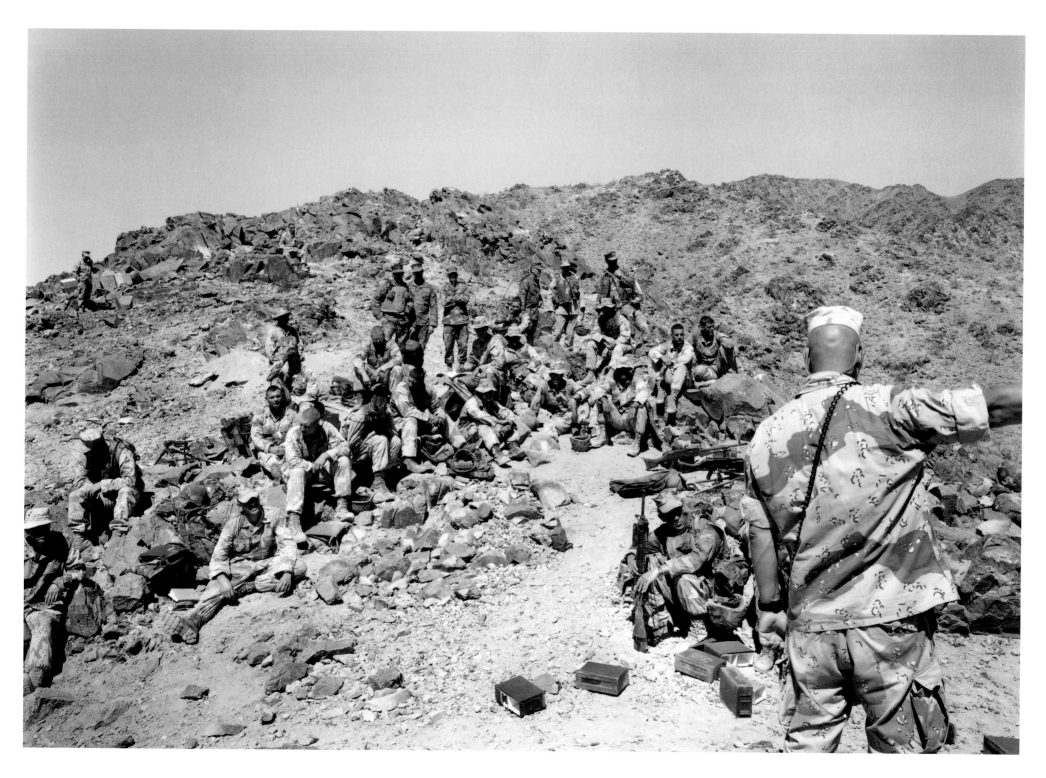

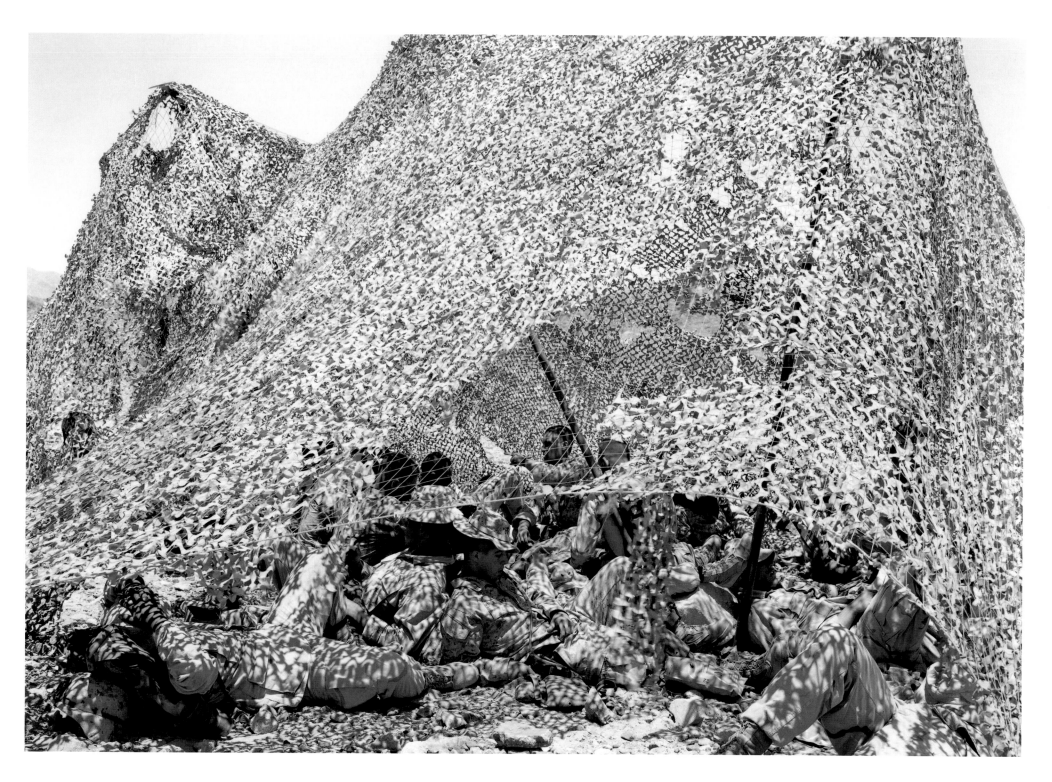

Infantry Platoon, Alpha Company, 2003–4

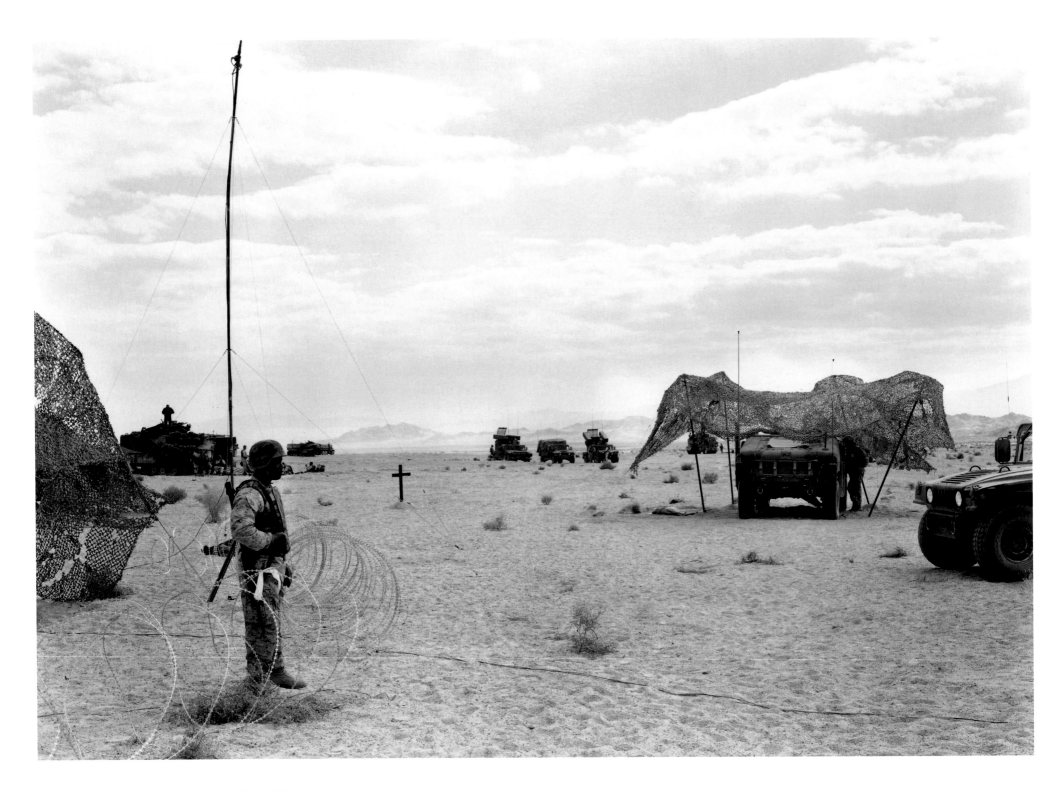

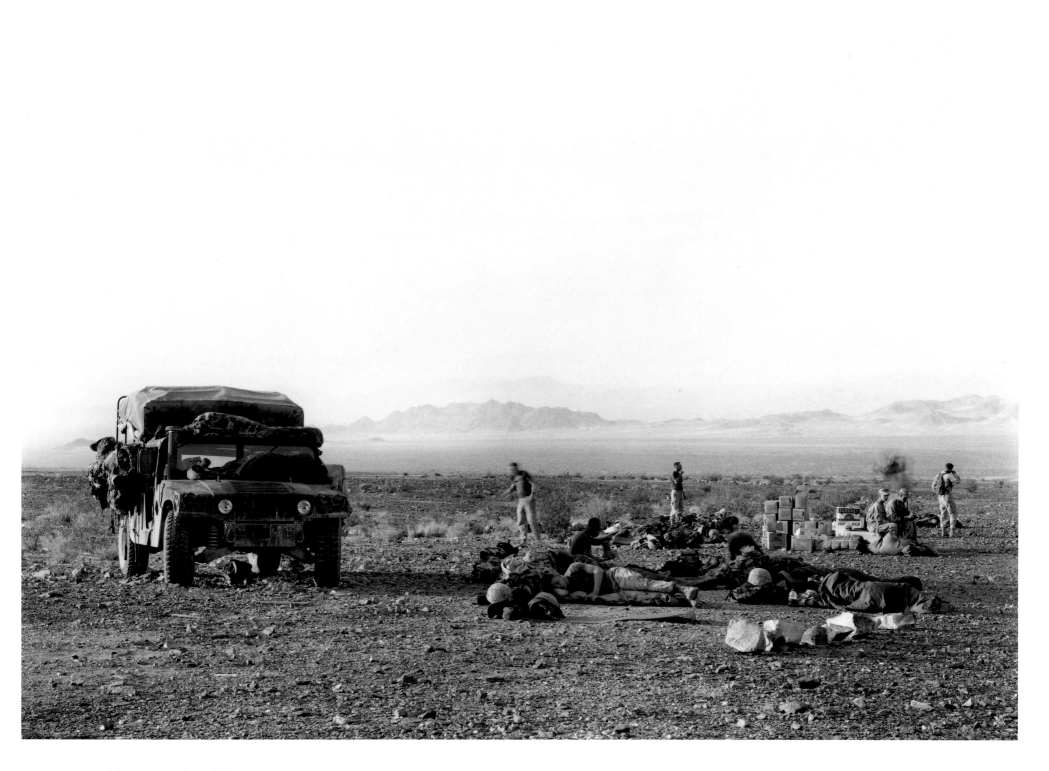

Infantry Platoon, Camp, 2003–4

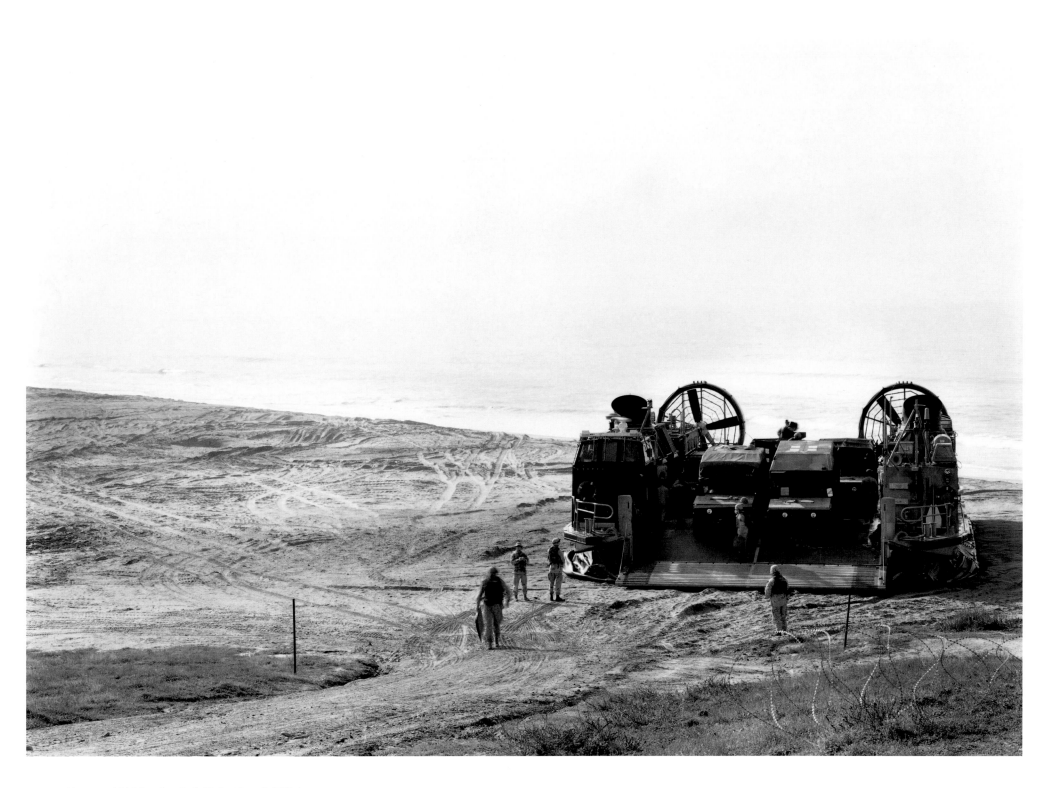

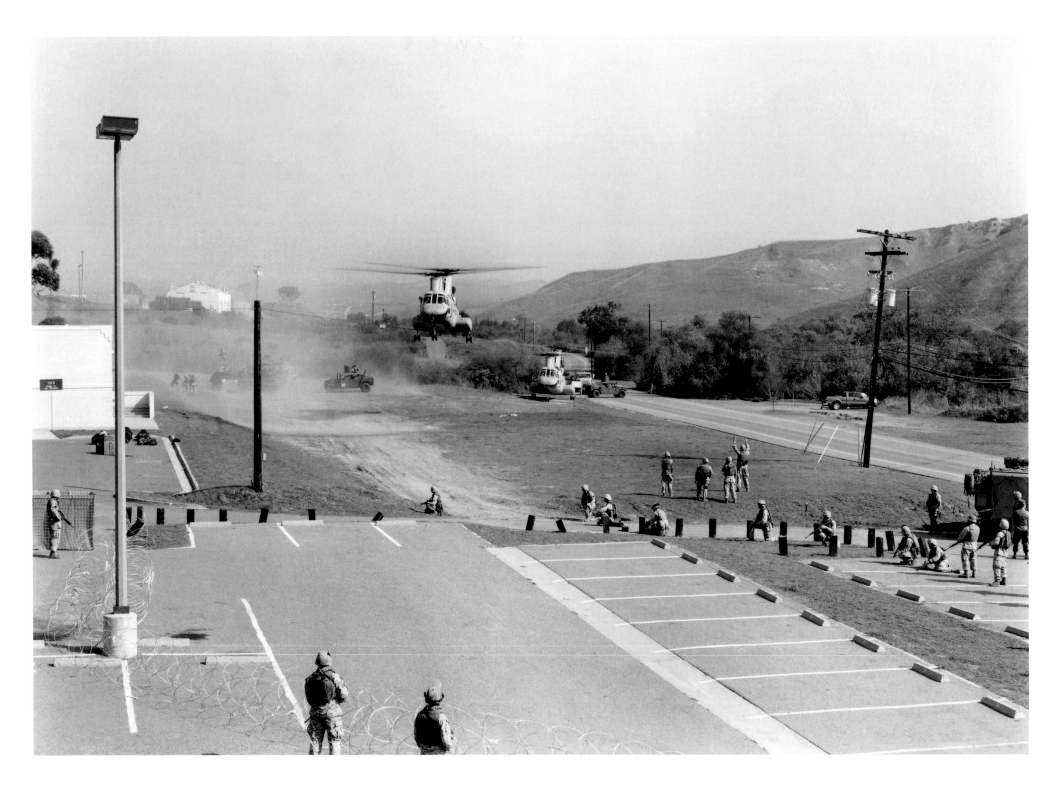

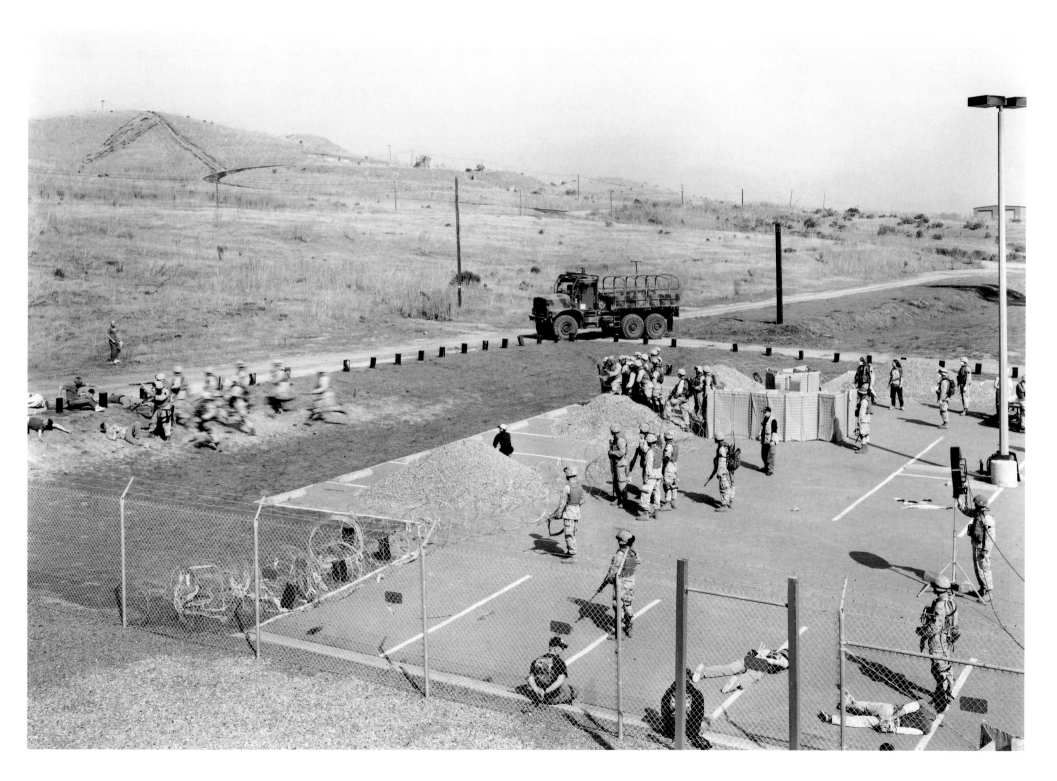

Embassy Reinforcement, 2003–4

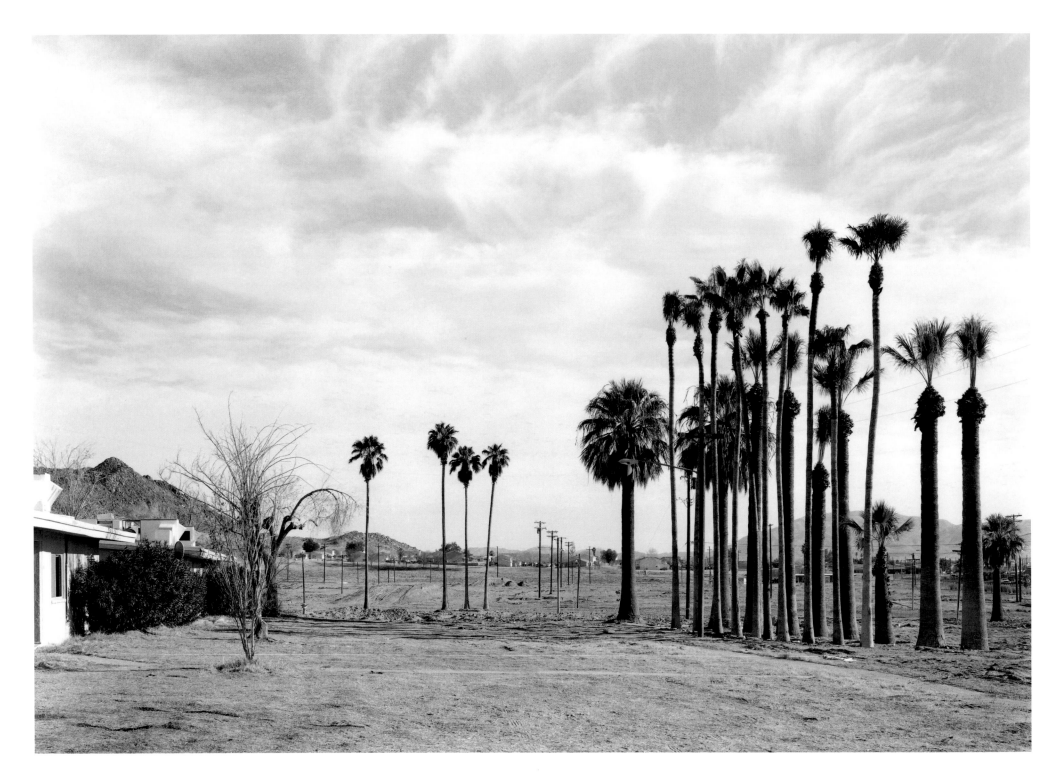

86 *Marine Palms, 2003–4*

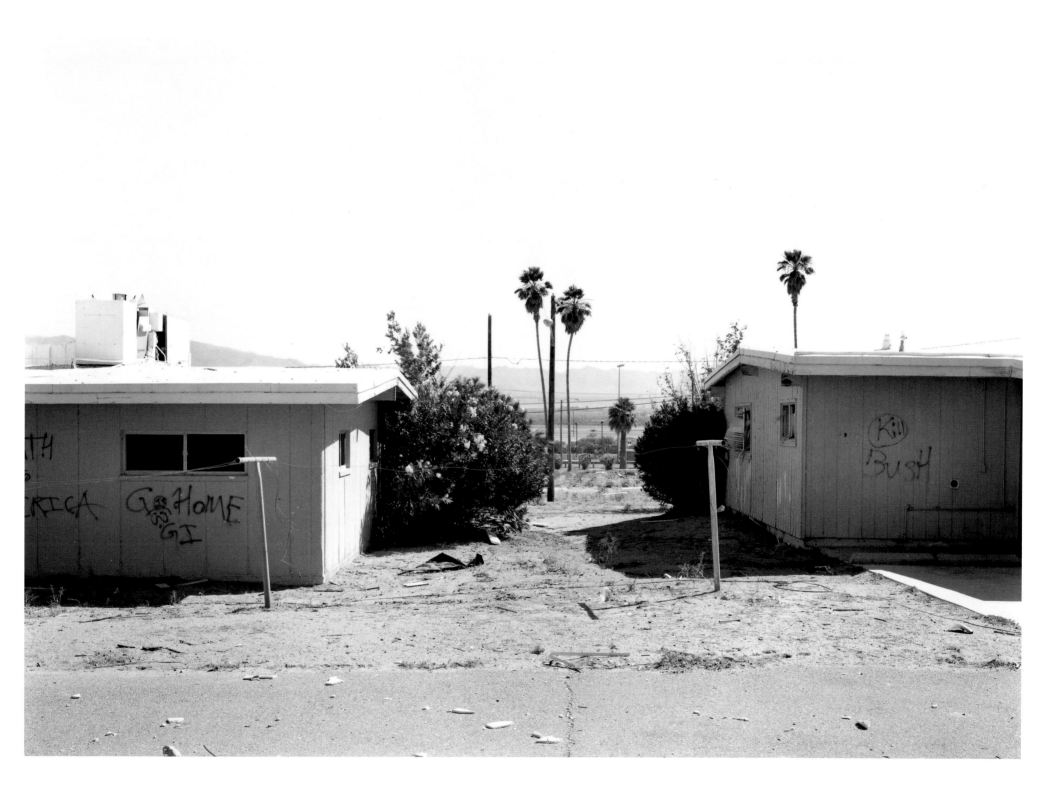

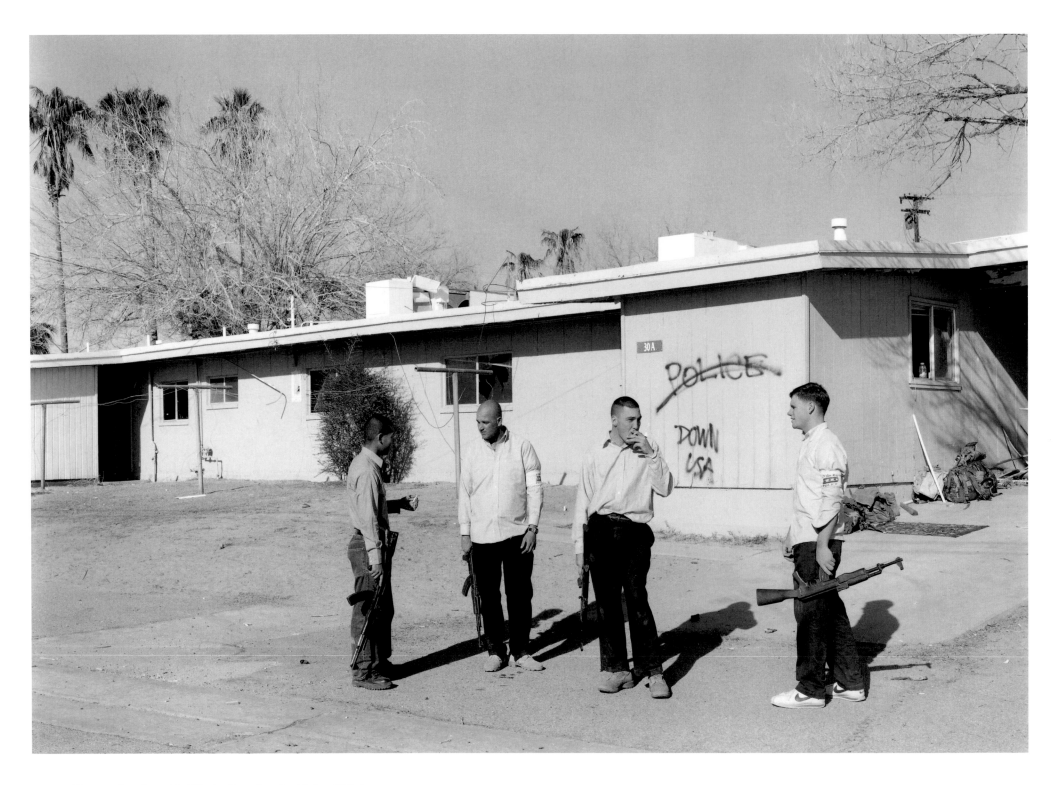

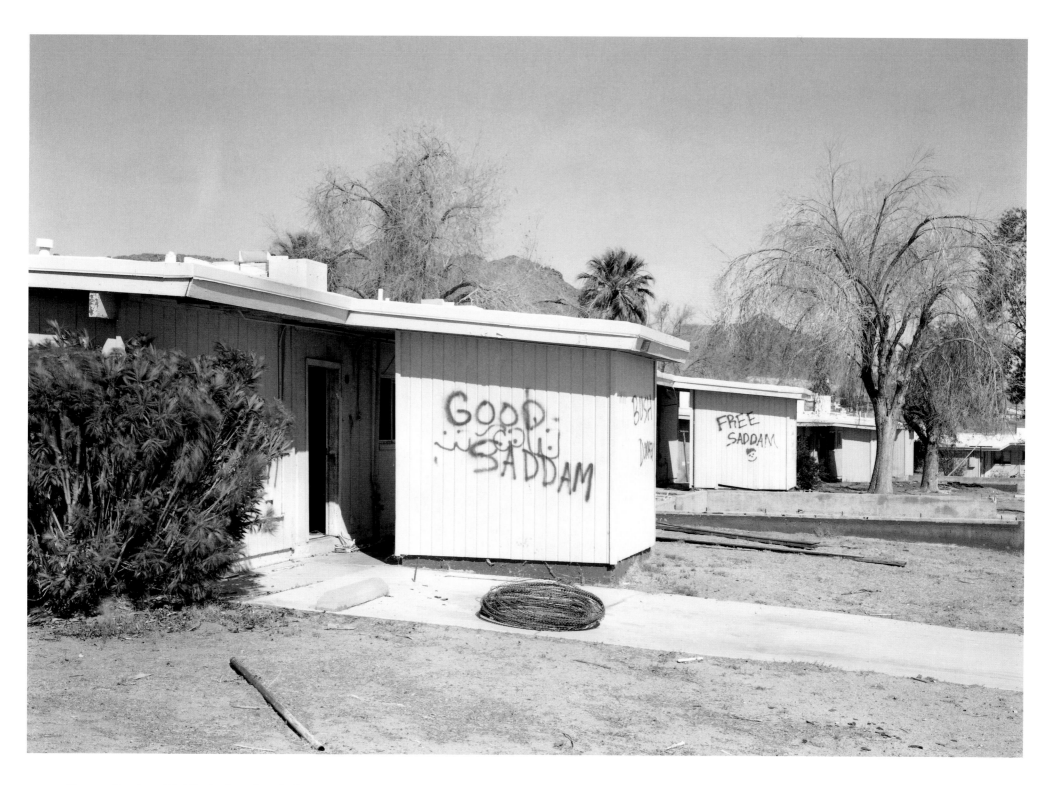

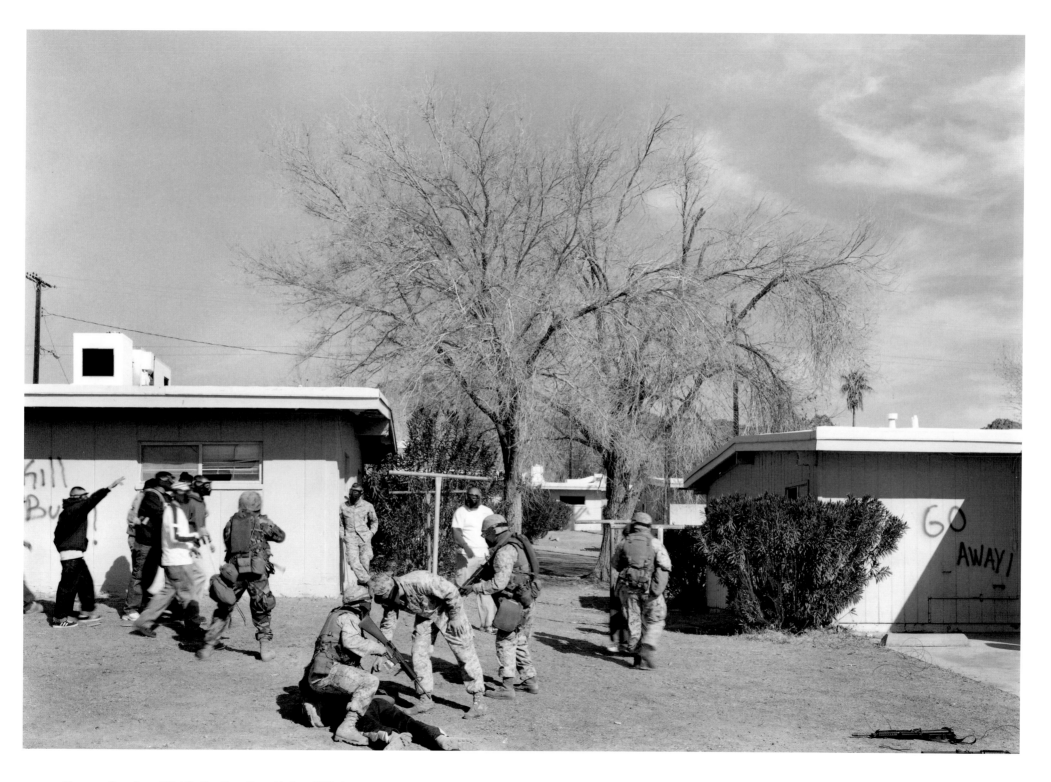

Security and Stabilization Operations, Marines, 2003–4

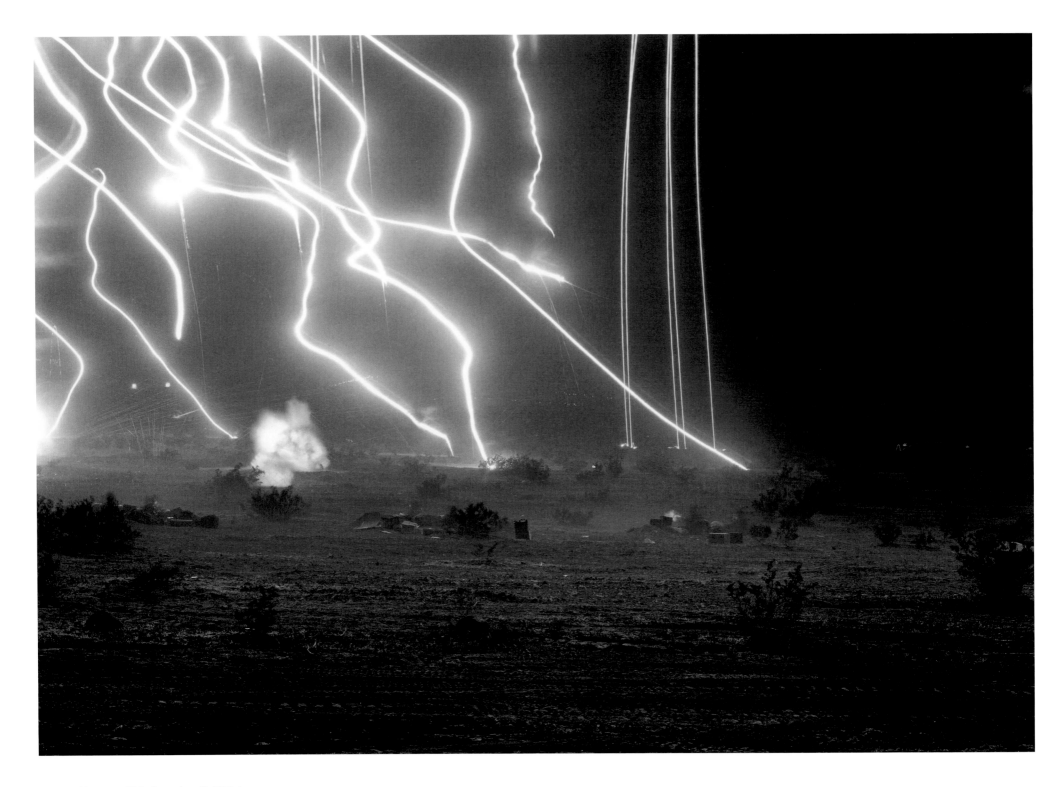

Night Operations III, 2003–4

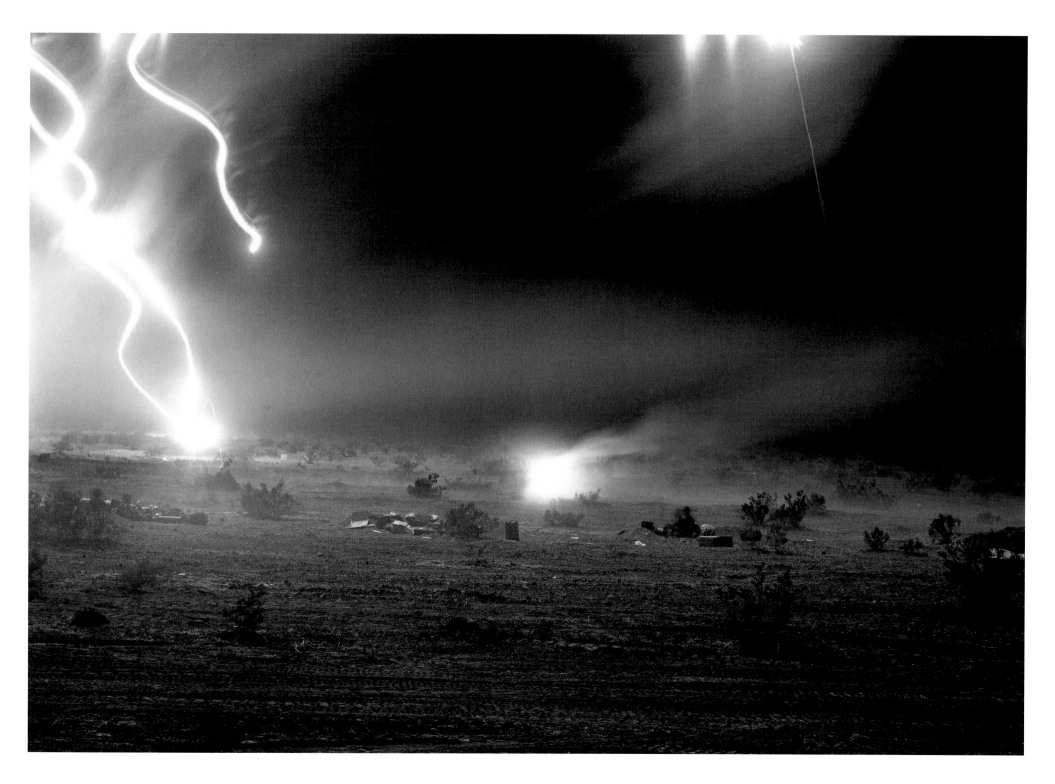

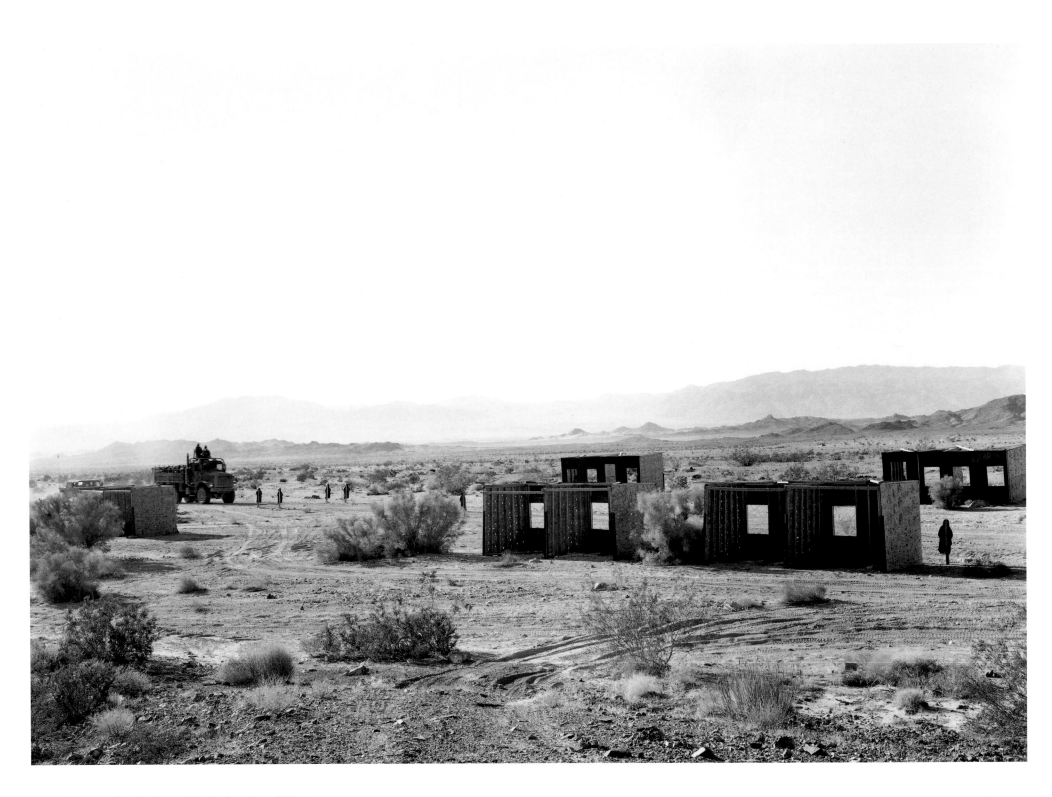

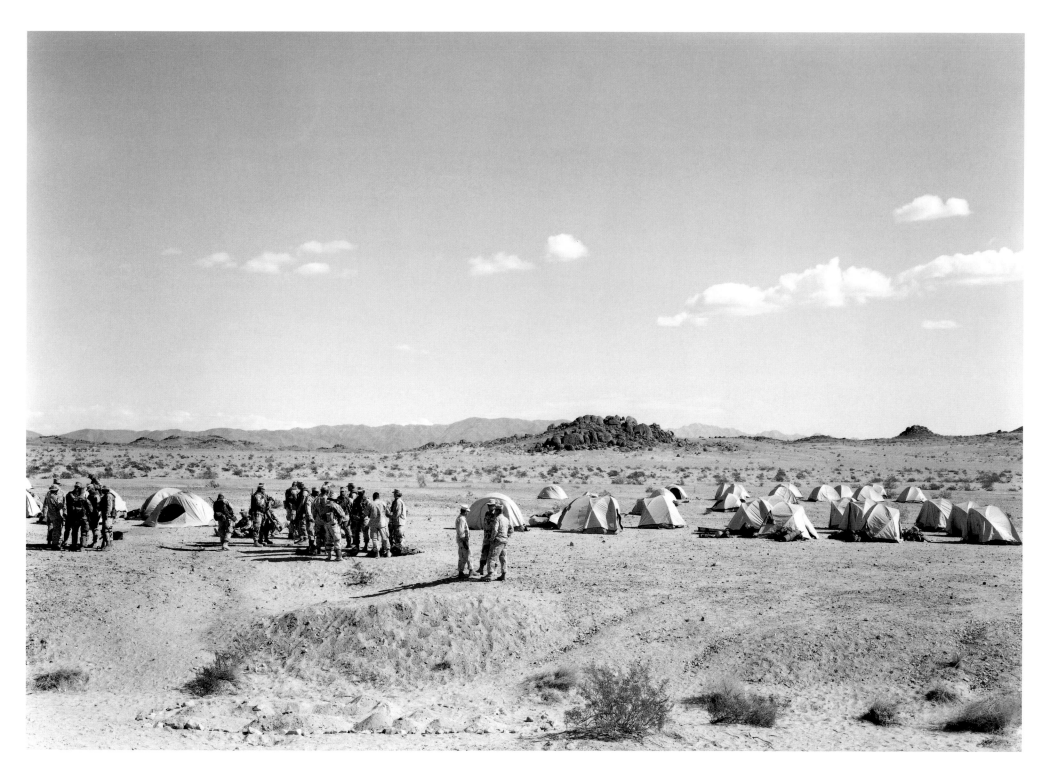

95 Bivouac, 2003–4

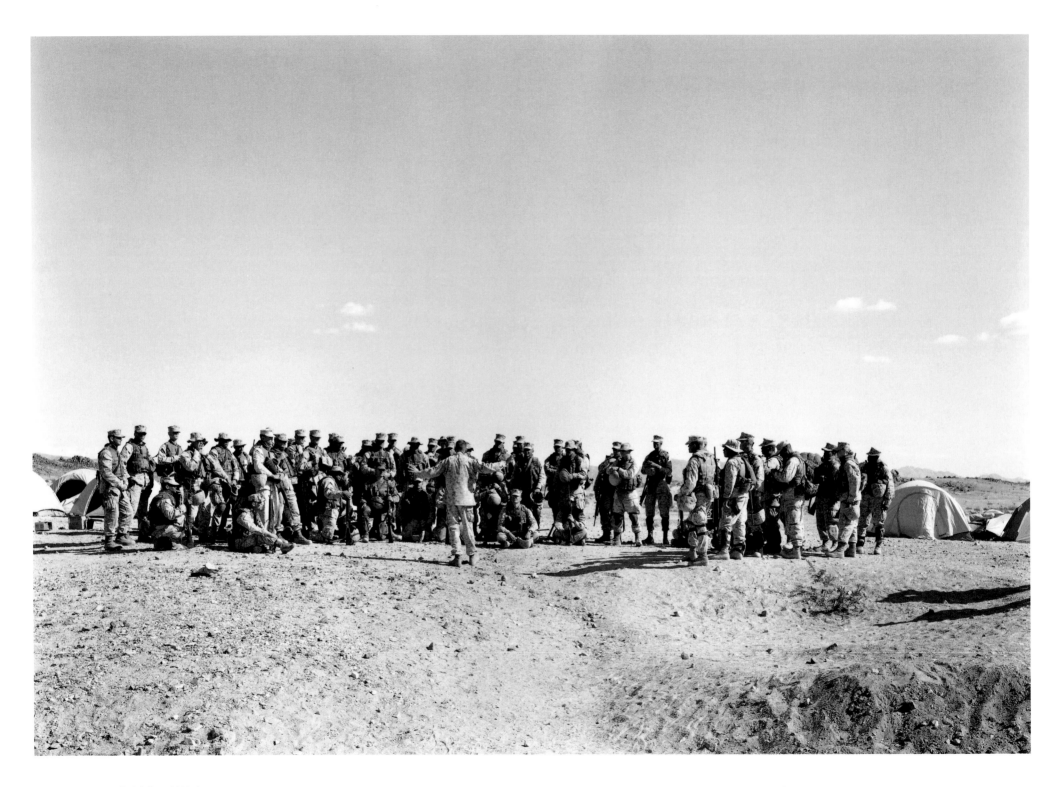

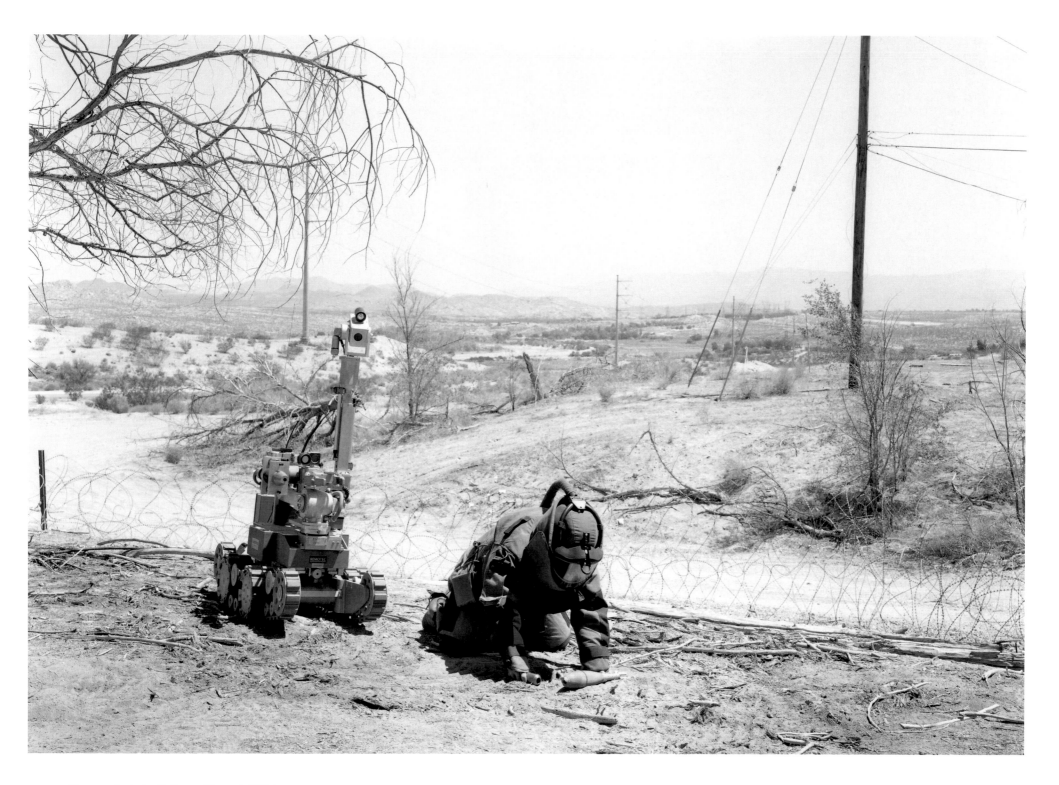

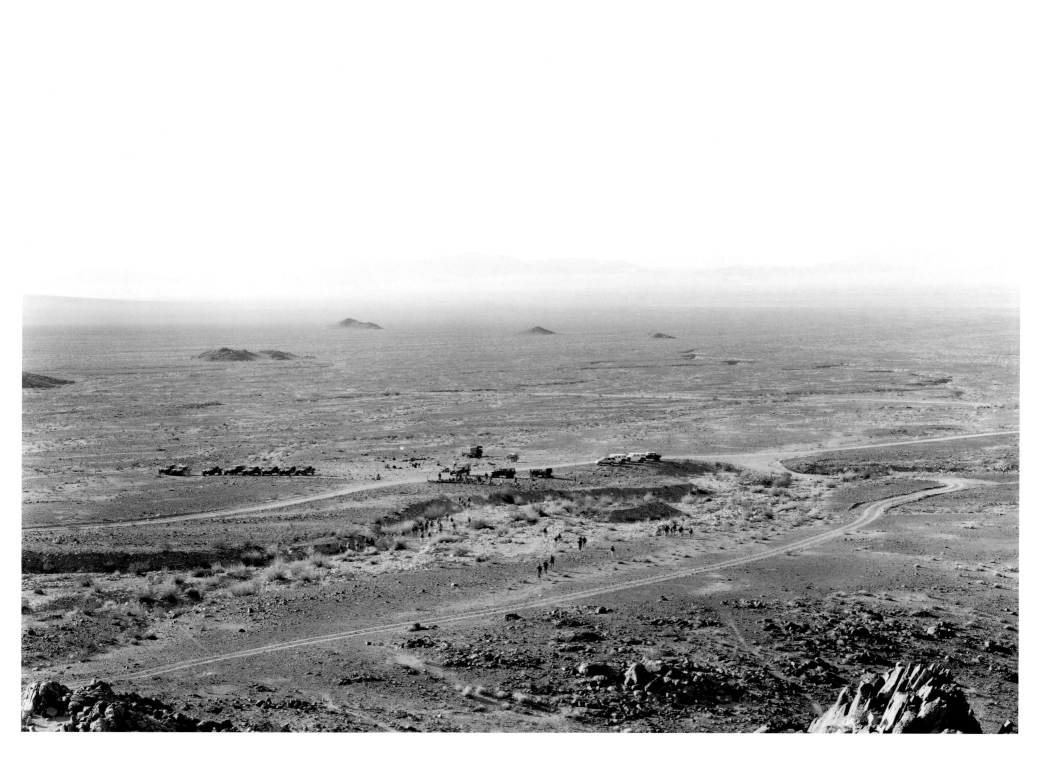

99 *Infantry Platoon, Attack, 2003–4*

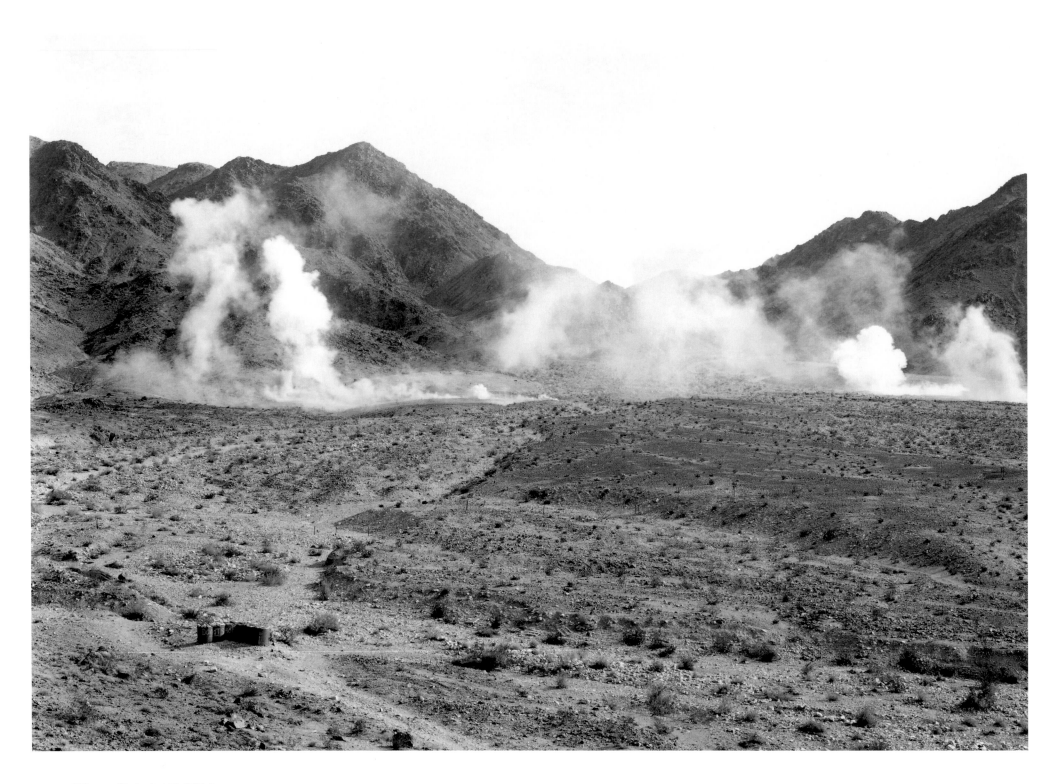

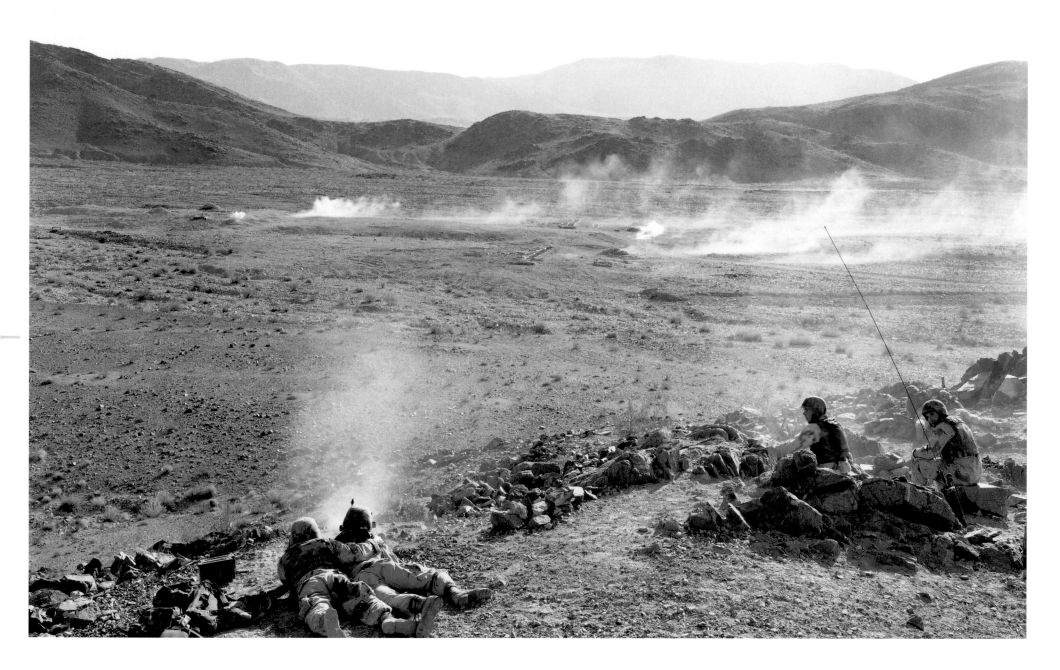

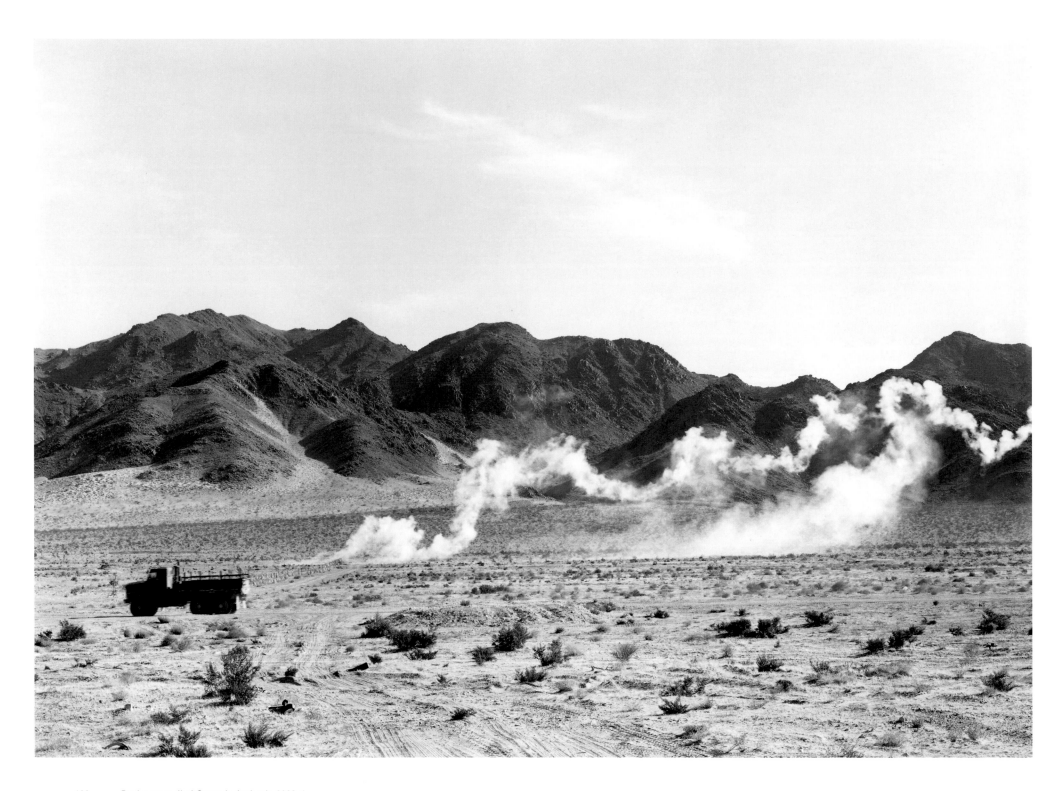

Rocket-propelled Grenade Ambush, 2003–4

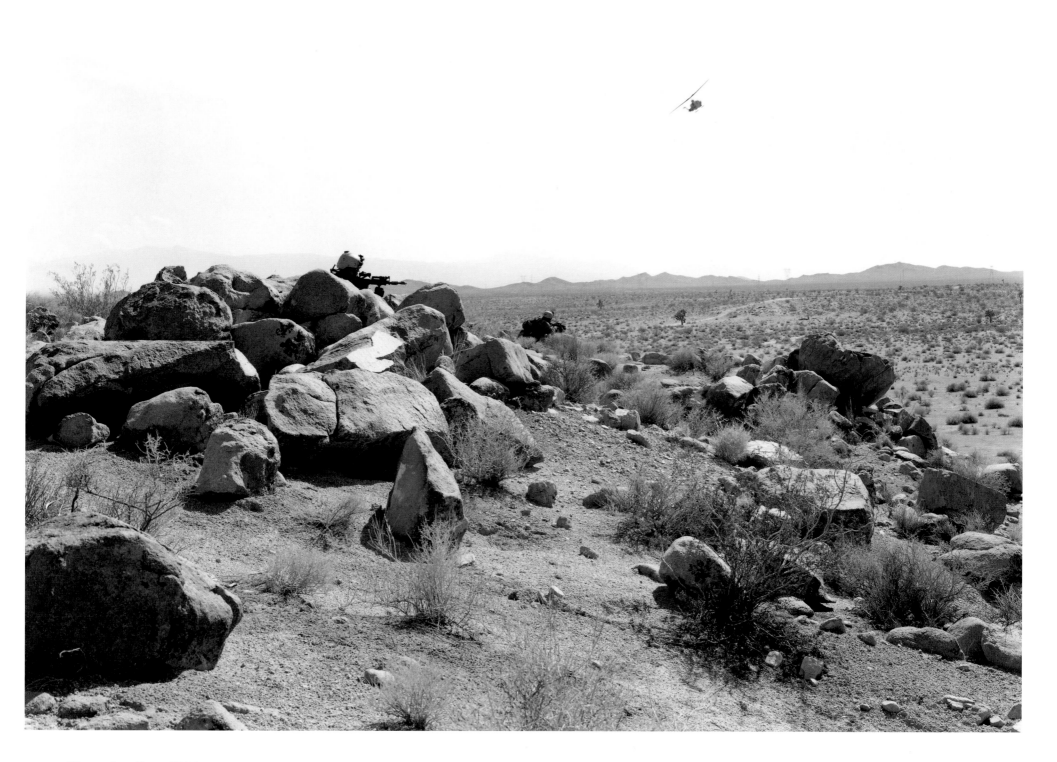

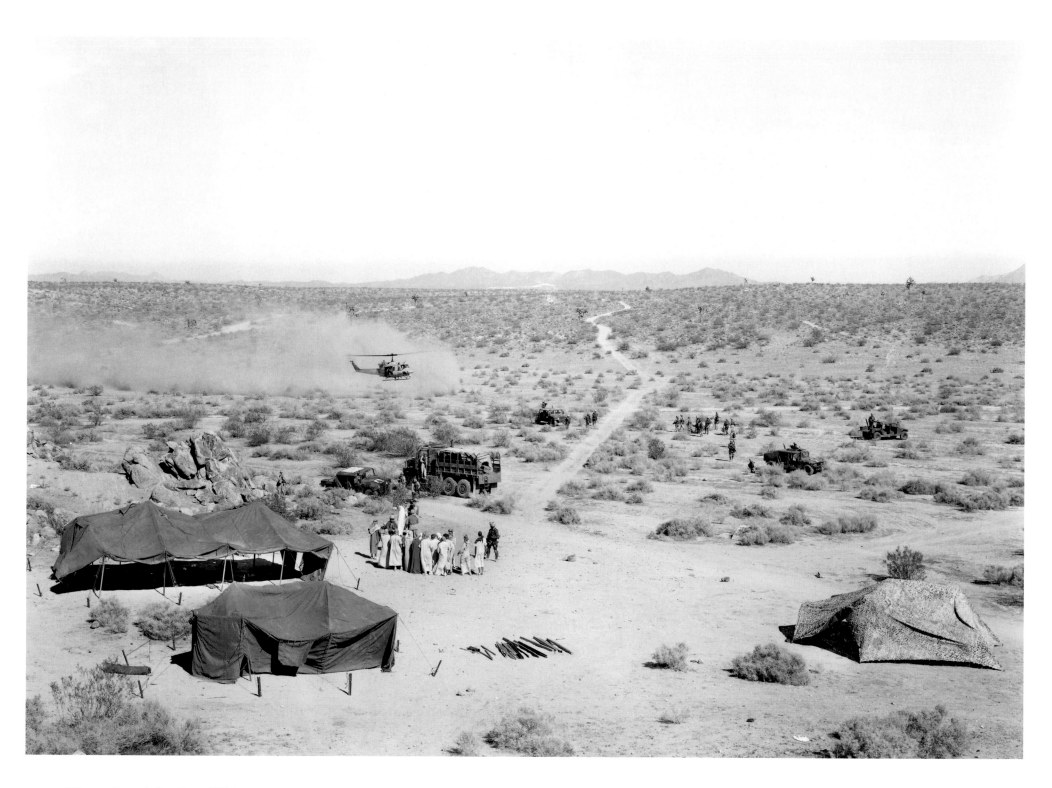

Resupply Operations, 2003–4

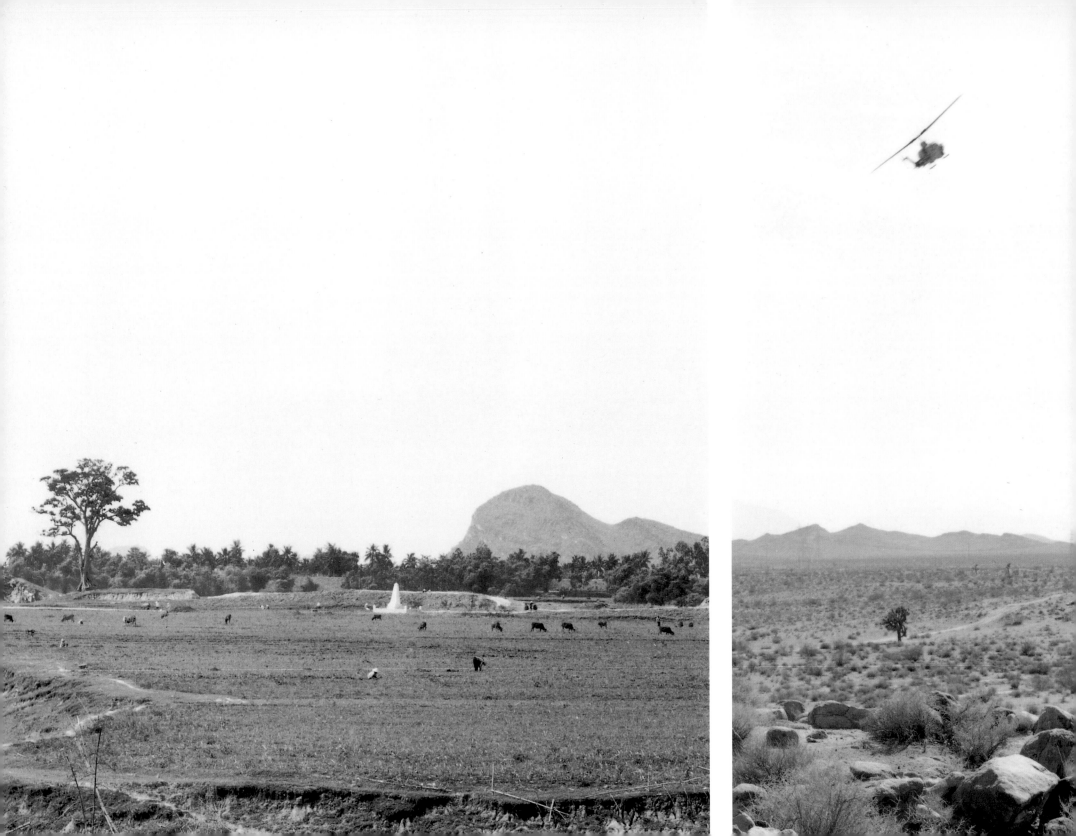

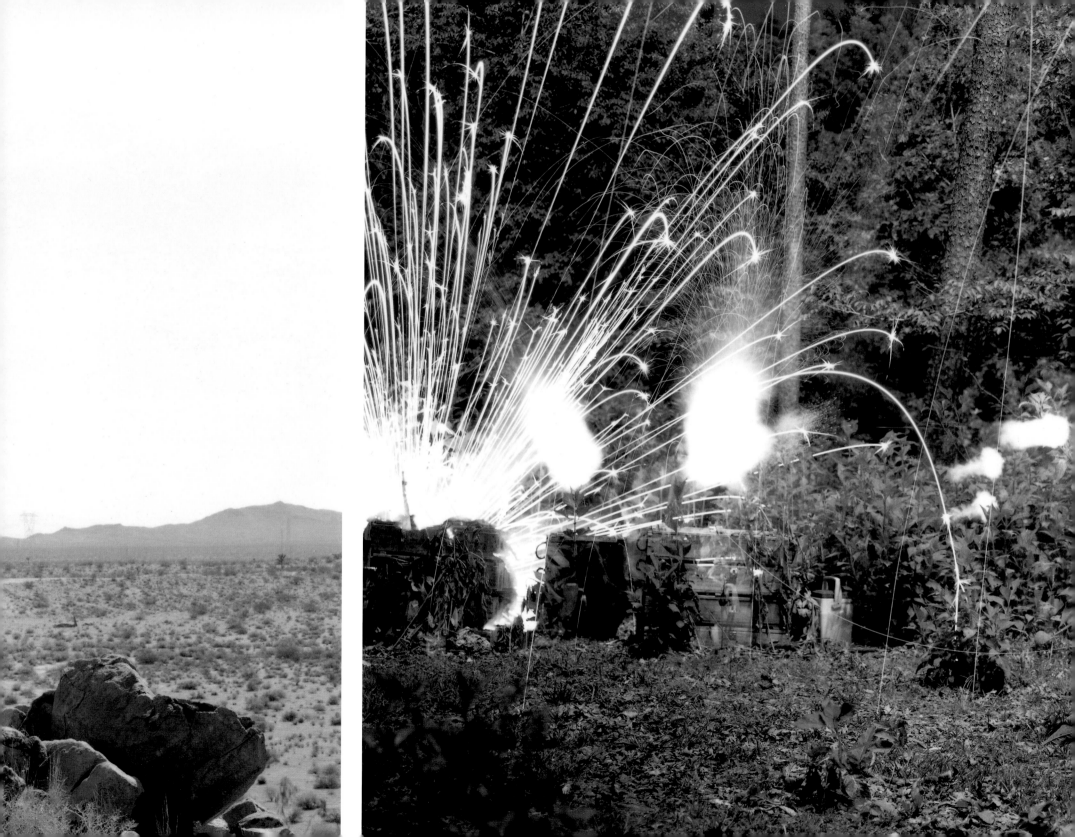

ESSAY: RICHARD B. WOODWARD

Geology and photography did more to upset conventional views of landscape and history than perhaps any other advent of the early Industrial Age. They may now belong to different realms—science and technology—but in a sense they grew up together in the 1830s. Both were disruptive elements in their early days, despite the fact that they could trace their intellectual pedigree back to the research of two eminent British gentlemen-scholars: Charles Lyell and William Henry Fox Talbot.

It was Lyell's *Principles of Geology,* published in three volumes between 1830 and 1833, that popularized and expanded the "uniformitarian" theory. This revolutionary concept, proposed initially in 1788 by geologist James Hutton, held that the Bible was seriously in error. The world had come into existence neither in the doctrinaire seven days decreed in Genesis nor, as more liberal churchmen allowed, only a few thousand years before Christ. Instead, the uniformitarians asserted, the land everywhere—visible on the earth's surface and buried from sight—had been built up gradually, drop-by-drop, almost immeasurably slowly, via common processes of nature that were, they observed, still at work. Erosion and sedimentation over millions of years—not Noah's flood or other catastrophes, real or imaginary—explained the contours of hills, valleys, and rivers, as well as the fossils embedded in the earth's crust.

Lyell's volumes secured an important victory for the uniformitarians over the catastrophists. Although in the past fifty years, scientists have turned up plenty of evidence in fossil records indicating that violent events such as meteors and volcanoes have repeatedly devastated the earth,[1] Lyell's influence in his day was enormous. Charles Darwin took along a copy of *The Principles of Geology* on his fateful 1838 sea voyage aboard the HMS Beagle, and often mentioned the book's importance to his theories of evolution.

Talbot was not the first to make a photograph—Nicéphore Niépce has been accorded that honor by historians. But it was Talbot who, in the 1830s, discovered that exposing a piece of paper to light inside a camera mounted with a glass lens could (if the paper were embedded with a substratum of silver iodide and, after exposure, washed in a bath of gallic acid, silver nitrate, and acetic acid) bring out a latent and fairly permanent negative image. Years of experiments led to what Talbot called the calotype, made with the negative-positive process: the basis for modern photography until the digital age.

The repercussions of Lyell's and Talbot's researches were numerous and in certain ways related. Both shattered previous ideas about time and mortality. Lyell proposed that the history of the land must be far more vast and complex, physically and chronologically, than anyone had supposed. The many layers of plant- and animal-fossil deposits indicated that our history as a species was minute compared with the eons when other organic forms—many now extinct—had inhabited the earth. Once the earliest igneous rocks were included in a timeline of the earth, the presence of humankind on the planet dwindled to almost nothing.

Talbot, for his part, demonstrated that a photograph was like a fossil. The world in front of the camera's lens or an object placed above or on a sheet of photographic paper left a ghostly but indelible imprint. This could, he suggested, be presented—if need be, months or years later—as evidence in a court of law.[2] For historians, detectives, and one's own grandchildren, a photograph could serve as a new kind of proof that a person, place, or thing had once existed.

If Lyell's writings stretched the history of time so that it became an all but incomprehensible abstraction in relation to individual lives, then Talbot's invention compressed and "trapped" it, making visible time's palpable interaction with earthly things during their exposure to light from a star. Photography was a chemical process for transforming and preserving time.

When nineteenth-century photographers took their cameras into the landscape, many carried along with them concepts that derived from Lyell. Notions of the sublime and the picturesque could be strengthened by scientific observation, noted John Ruskin, who called on artists to study botany and geology.[3] The debate between the uniformitarians and catastrophists, reignited by Darwin's even more

Timothy O'Sullivan, *Rock Carved by Drifting Sand Below Fortification Rock,* Arizona, 1871

astounding theories, found expression both in painting and photography.

Timothy O'Sullivan was a staff photographer on the 40th Parallel Survey of the American West, led in 1867–72 by the geologist Clarence King, a Yale graduate and a Bible-quoting catastrophist. Scholars are undecided as to how much, if at all, O'Sullivan's pictures of desolated land were made to reflect King's theories about God's terrifying wrath.[4] But a popular strain in American landscape photography—running from Carleton Watkins and O'Sullivan to William Henry Jackson and Ansel Adams—has highlighted the special awesomeness of the West: the vast plains, deserts and forests, the saw-toothed mountain ranges strewn with mighty trees, waterfalls, scrub, and up-thrusts of volcanic rock, and the shrunken presence or complete absence of human beings.

The photographer An-My Lê practices her artistic craft in a manner that ostensibly belongs within the tradition of nineteenth-century landscape. Her negatives are composed with a large-format view camera (5-by-7) mounted on a tripod. Her prints are black and white, and for the most part untouched by digital techniques. The success or failure of her pictures thus depends primarily on her ability to capture a scene while standing in the field and looking through the viewfinder.

The point of view in Lê's pictures is likewise straightforward, in the style of a geologic-survey

photographer. She eschews early-modernist formal experimentation. There are no vertiginous tilts up or down, no monstrous close-ups of human faces. The blurred motion in many of her pictures is common in the work of nineteenth-century photographers, whose slow shutters were unable to freeze rapid action. In Lê's case, the blurring is often a choice, an antiquarian gesture that puts her at odds with the aesthetic of edge-to-edge sharpness that prevailed in photography throughout most of the twentieth century.

Lê photographs the world as though from a great distance—formally and emotionally. A sense of her own removal, in both space and time, from the scenes depicted is evident on every page here. The unsentimental coolness of her eye and the exquisite soft-gray palette of her prints can cause temporal confusion in the audience. Even her most recent group of pictures, views of U.S. soldiers training for active duty in and around the deserts of 29 Palms, California, have a science-fiction quality, as though she were recording events from decades or perhaps centuries ago. Based on up-to-the-minute subject matter, her oblique commentary on the fractious Iraq War nonetheless exhibits a stateliness, a classical reserve more in tune with Poussin's scenes of Greek and Roman antiquity than with photojournalism.

As a Vietnamese political refugee who arrived in the United States in 1975 at the age of fifteen, Lê is on intimate terms with the rupturing effects of war.

Disjunction and displacement are profound themes in her work. But however crucial for her own life this historical schism may have been, its violence has been indirectly experienced, and further distanced and distorted by its representations in American life. This perspective, convoluted though it may be, unifies the photographs in this book, the title of which is potentially misleading: there is of course nothing "small" about the consequences of war, or indeed about Lê's talent.

Lê took up photography in 1985, more than a century after Timothy O'Sullivan's death. Even though during this interim the glorious legacy of Western landscape photography had continued to flourish, and was until 1984 vigorously alive in the revered figure of Ansel Adams, many young and serious photographers had by the 1970s begun to spurn what they perceived as his outmoded and fustian romanticism.

By then it was another Adams—Robert Adams—who was guiding contemporary practice with his more modest but no less eloquent views of the West. Featured in the landmark *New Topographics* exhibition in 1975 at the International Museum of Photography, George Eastman House,[5] along with Lewis Baltz, Joe Deal, Stephen Shore, Frank Gohlke, Henry Wessel, Jr., John Schott, Nicholas Nixon, and Bernd and Hilla Becher, Adams shared

with this group a fascination for the industrial and postindustrial landscape. In their study of this subject, all of them tended to employ the by-then "outdated" large-format cameras to document the mutating, cumulative, often altogether devouring effects of human beings upon the planet.

The organizer of *New Topographics,* William Jenkins, traced this somewhat ironic landscape sensibility back to Ed Ruscha's serial images of gas stations and parking lots from the 1960s, although many earlier photographers—including Ansel Adams—certainly did not ignore mankind's intrusive presence. But if Ansel Adams more often extolled the Edenic wonders preserved in the U.S. National Parks, this new generation thought it was about time to notice the housing complexes that now surrounded them. What's more, they welcomed the challenge of converting a banal subject, such as a prefab ranch house or a logging road, into a photograph that was true and beautiful in its way—beautiful because true.

The problem of thinking about landscapes without nostalgia found another imaginative solution in the work of geologist-turned-photographer Mark Klett. In his three-year undertaking with Ellen Manchester and JoAnn Verburg, "The Rephotographic Survey Project," begun in 1977, a group of photographers was assigned to revisit 120 of the sites memorialized by O'Sullivan, Jackson, J. K. Hillers, William Bell, Andrew Russell, and others who had worked on the nineteenth-century Western surveys.[6] Contemporary

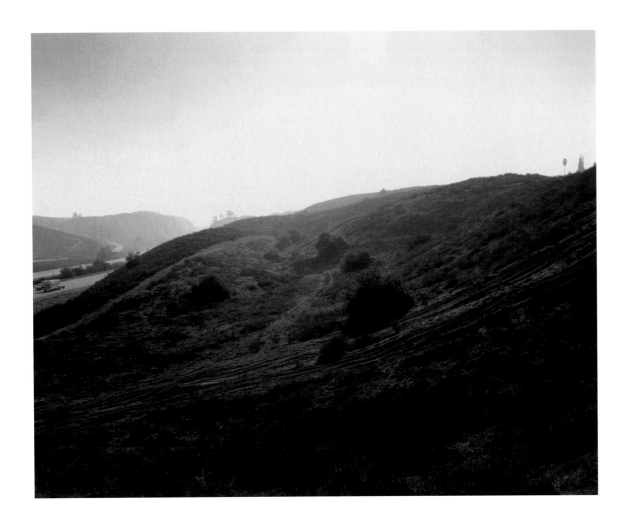

images were made to match, as closely as possible, the same vantage points and weather conditions as the originals. Old and new plates were presented together as a comparative record of those places— some of which had been virtually unchanged by a century of population growth, and others that had been altered beyond all recognition. Photographs, which cut instants out of the world but leave it intact, were here used to measure out evolution over the course of a century or more—a span that in human terms might be said to approximate geologic time.

When Lê graduated from Yale and set off for Vietnam in 1994—the first time she had been back to her home country since her departure in 1975—she did not intend to photograph landscapes. Instead, pursuing a theme that was then prevalent in the art world, she was constructing "autobiographical still lifes" for the camera. Her initial plan was to collect a set of meaningful objects in Vietnam and to photograph them.

That is not what happened. Instead, with a mental map of places she remembered from her childhood in the South, and a list of others provided by her mother, whose family had grown up in the North, Lê began to take pictures that sought connections, if any existed, between her contemporary self and the landscapes of her birth. The culmination of this three-year project was its appearance in *New Photography 13,* a 1997 group exhibition at the Museum of Modern Art in New York.

Lê's photographs address the issue of nostalgia and the limitations of her medium in uniting present and past. Because they embed time into their own creation, photographs are in a sense the perfect aide-mémoire. But the memories they conjure up are a tricky, unstable blend of the false and the true—in the manner of most memories. Even if the trip back "home" afforded her a sense of belonging again to a majority who shared her genetic ancestry—a common sensation as well for black Americans who return to Africa—too much had changed in the nearly twenty years since Lê's exile for photography alone to close the gap. Her images are as much about estrangement as about homesickness, and serve as evidence of an unbridgeable void. The sense of calm and order in the preindustrial countryside holds out a deceptive promise of a return to a simpler time.

Lê can't help noting her exclusion from this world. A house with a path leading up to the front door is boarded up (page 10). Her camera records—without alarm or condescension—the impoverished architecture in the country she left behind: concrete and stucco constructions; windows without glass; a gymnasium barren except for a desk and two chairs; brick buildings that have been left as rubble (page 17). Fantastic reminders of the war can be seen in a plume of smoke that rises from a house beside a river (page 16) and in the jetlike shapes of children's kites darting across the sky—death from above (page 27).

But the people whom Lê portrays—usually as groups rather than individuals—seem neither distressed nor alienated. They are at home in the landscape. She, on the other hand, is an American photographer who no longer belongs in this twilight world, one that has continued at its steady agrarian pace for centuries, and that has adapted to her twenty-year absence with remarkable ease. The two worlds are merging—she observes in the wooden boats oaring toward billboards for Sanyo and Xerox the pull of modernity (page 37)—but she seems no happier about that development either.

Lê's Vietnam landscapes are, like Klett's project, a kind of "rephotography"—except with half-remembered places to revisit instead of documented, impersonal ones. Carrie Mae Weems, in her 1991–92 "Sea Islands" pictures of the African diaspora, similarly explored the concept of place as a lingering wound. Lê's series also resembled Joel Sternfeld's "On This Site"[7] project from 1996, for which he took his camera back to sites of historic, often violent tragedy—the road shoulder where Rodney King was beaten by the Los Angeles police, or the clinic where a doctor who performed abortions was shot in the back three times. In virtually every case, the places chosen by Sternfeld bore few or no traces of their past. Time had "cleansed" them as scenes of horror, but had left another kind of chaos behind; motorists and pedestrians now passed, apparently oblivious that their suburban schoolyards, local streets, city bridges, and traffic intersections had once been blood-soaked ground. The history of the earth, as both Sternfeld and Lê demonstrate, runs on a timeline separate from the history of human actors. The journeys of both artists, which started out as bids to recapture the past, end up as proof that nostalgia—that seductive emotion so often associated with photographs—is no match for the amnesia of contemporary American life.

Lê's series on military reenactors, titled "Small Wars," is another study of misplaced hopes and false memories. The project was begun in the summer of 1999 and completed four summers later. The photographs were exhibited at the P.S.1 Contemporary Art Center in Queens, New York, a setting that accentuated their status as unconventional works. Almost as quiet as her Vietnam landscapes, these images have a more daring autobiographical dimension and an even more slippery set of meanings.

Military reenactment is an international movement that stretches from the United States across Europe to Australia. Although many enthusiasts prefer to describe their events as "living history"—stressing that the scope of their concerns goes beyond the battlefield—membership is decidedly male and oriented around issues of war. American reenactors get together on a regular basis to re-create combat from the Revolutionary War, World War I and II, Korea and Vietnam.[8] Most prominent may be the tens of thousands of Civil War reenactors, whose quixotic obsessions are the subject of Tony Horwitz's 1998 book *Confederates in the Attic*.[9]

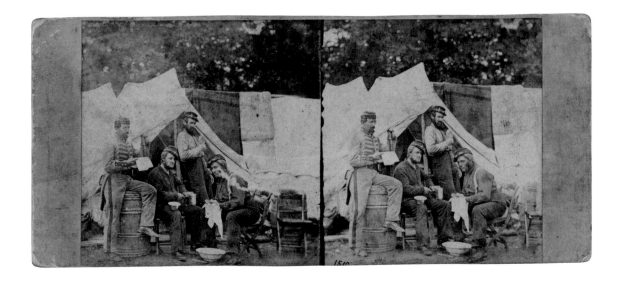

The quest of every "living historian" or reenactor is authenticity, an elusive, even impossible goal, because dreams of the past continuously smash into the realities of the present. Using blanks instead of bullets, these men can easily spend two hours running around in the woods just out of sight of an Exxon gas station, in what is supposed to be a fair copy of the murderous conditions at the Battle of the Bulge. Reenacting is inevitably an exercise in fakery.

It is tempting to view reenactments as examples of Disneyfication—as the triumph of the simulacrum (*pace* Jean Baudrillard): the rendition that becomes a preferred substitute for lived experience.[10] The

reenacting movement in the U.S. took off only after about 1975, when the end of the Vietnam War diminished the risk of dying in actual combat. The majority of military reenactors have never seen military service.

But the sincerity of these hobbyists should not be doubted. While some join up merely to enjoy the freedom of shooting off a gun, many are dedicated military historians. They want to better understand what their ancestors, fathers, or brothers had to endure as soldiers. They are hoping to touch history and commonly refer to themselves as "time travelers." The blissful goal of every participant who

spends hours driving to a pretend battlefield comes when, amid the confusing smoke and sound of firearms, he feels himself slipping back into the past, if only for a few moments.

Lê entered this world of illusion as a stranger in every sense of the word. As a Vietnamese woman documenting a group of Southern males who were replaying an imaginary Vietnam War in the woods of Virginia, she expected a hostile reception. And yet in her role as a photographer she was quickly welcomed as a participant. Her view camera added a note of legitimacy, even dignity, to the somewhat low-rent activities. Even more crucial to her efforts to fit in with these surroundings, her biography lent some measure of "authenticity" to the exercises.

At least two armed parties are required to fight in any pretend battle, and Lê, because of her background, was at times called on to represent "the other." The highlights of these four summers—and, one suspects, for Lê herself—were those instances when she was required, for the purposes of evening up the sides in the charade, to step from behind her camera, don black pajamas, hide in the bushes with a gun, and play "the enemy" (pages 57 and 67). Her alien status in this peculiar situation ensured that she would have a critical role to play.

Lê's respectful treatment of this folly is remarkable. Nothing in her photographs can be construed as mockery, although we can be sure that at times she found these men and their gunplaying

more than a little silly (in all likelihood, so did they). She would have been fully justified if, in her role as a female photographer—and perhaps in her subjects' eyes, an "Oriental"—she had chosen to reverse the history of exploitation as outlined by Edward Said. Instead, in an act that is both generous and subversive, she presents these armchair soldiers as they would likely hope to be seen.

Throughout the "Small Wars" series, which begins with a group of commandos in a version of Vietnam, defending a smoking American jet (page 41)—a genuine jet, even if not downed by antiaircraft fire—Lê's camera stands at a polite remove from the proceedings. The subtle tonality of her prints helps to maintain the illusion of these men that they are camouflaged warriors engaged in jungle combat (pages 43–45). But Lê also takes note of the anomalous presence of southern U.S. pine trees in these "Vietnamese" settings (pages 46–47); and she never pretends, as do many photojournalists, that she is giving us the inside story. These pictures don't take us inside anything. There is no inside to this story.

The fake war is acted out in the flesh, and is in this respect quite distinct from David Levinthal's project "Hitler Moves East."[11] That wildly original series and book, created with toy soldiers and miniaturized sets while Levinthal was a graduate student at Yale in the 1970s, was literally a "small war" that mimicked representations of a larger one. Lê's "Small Wars," with its human role-playing, has closer alliances with Cindy

Sherman's "Film Stills" or Nikki S. Lee's assimilation pictures. Lê inserts herself into the frame only on rare occasions, but her pictures are, nonetheless, very much about the performing self.

Finally, however, Lê stands separate from all of the above in her unwillingness to sacrifice the traditional values of photography. The landscapes in this book, realized from the simplest elements—leaves and trees and bare fields and cactus hills—compare in their grace and understated craft with the finest photographs of Robert Adams. Lê manipulates the film back and bellows of her view camera to bring a hanging tree or a flock of geese into accordance with the rest of the elements in the frame. But this coercion is hard to detect. When she drops or raises the horizon line to emphasize a set of clouds, or to rhyme the blank sky with the blank desert foreground, the execution is in line with Henri Cartier-Bresson's dictum that the photographer should always have "a velvet hand, a hawk's eye."[12]

Her large-format camera is an old-fashioned device that demands meditative care and preparation. It allows her, she says, "to look at the layers of the objects in front of me, and feel the air flowing through things." Its antiquity also connects her pictures of postmodern inauthenticity to the work of America's Civil War photographers. The trials and banalities of soldiering are often no different from the trials and banalities of camping—a fact that many of Mathew Brady's images of Union troops at ease confirm with

valiant honesty. This Vietnamese-American woman is no less committed to plain truths.

The clash between uniformitarians and catastrophists will perhaps never be settled and was again replayed in the second half of the twentieth century, in arguments about the writing and rewriting of history. The French Annalistes school[13] held that long-protracted, incremental changes had been at least as important in shaping human lives as the rise and fall of governments. Fernand Braudel, a leader of the Annalistes after World War II, studied climate, trade routes, harvests, birth rates, what people ate and wore, as the means of discovering deep and hidden patterns of change. These might be played out over centuries of time (*la longue durée*), and be obscured by the tendency of historians to focus on the snapshot of a violent and dramatic event, such as a war or the downfall of an empire.

Lê makes uniformitarian photographs of catastrophes. Her landscapes made in Vietnam, Virginia, and 29 Palms have more permanence than the people in them. In her photograph of American tanks, Humvees, and trucks during practice maneuvers for Operation Iraqi Freedom, it is the striations of clouds on the desert hills that catch the viewer's eye. It is hard not to see this pattern of sun and shadow as a comment on the looming futility of the Iraq War, which threatens to mire American troops for many years in the scorched land of the Middle East.

Roger Fenton, *Camp of the 5th Dragoon Guards*, 1855

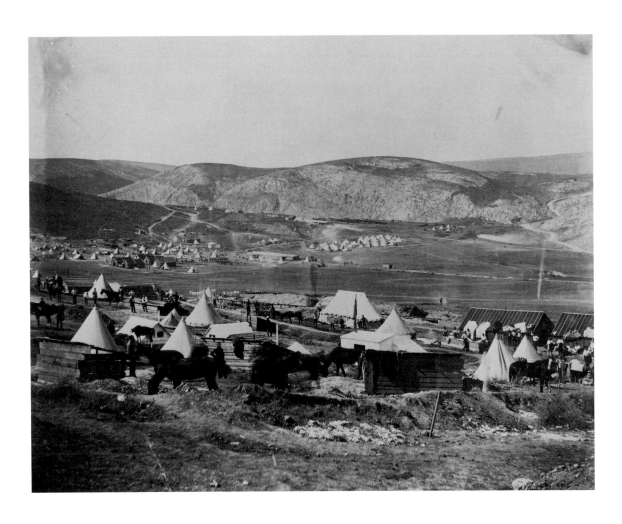

This latest series, created over the past two years, furthers Lê's investigations into war-as-theater and image-as-"news." Like the war photographers of the nineteenth century, Lê is recording indirect or staged violence at 29 Palms. Roger Fenton, in the Crimea in 1854, was able to capture the troops only in their bivouacs or drilling in formation. He depicted the aftereffects of battle in the iconic image *Valley of the Shadow of Death*; to record the actual fury of combat was beyond the technology of that time. O'Sullivan and Alexander Gardner were likewise limited at Gettysburg in 1863. To overcome this problem—and to boost both the gothic atmosphere and the cash value of their prints—American Civil War photographers sometimes staged scenes by moving corpses and rifles together from different sites on a battlefield.

In Lê's photographs, it is the U.S. military that is engaged in phony business. The slogans ("Down USA" or "Good Saddam") painted on the sheds of the homes are designed to enhance the feeling of authenticity in the training exercises, and to pump up the adrenaline of the would-be attackers on imaginary insurgents. But the haplessness of these "realistic" touches only underscores the grotesque sadness of playing war and the chasm between it and the genuine article. The evidence of a threat on the U.S. mainland that sparked this war, and for which many of these marines have been sent to risk their lives in Iraq, now seems to some as trumped-up as this graffiti.

History has a geologic thickness, as well as a layered and wraithlike presence, in many of Lê's photographs. Her pictures of the desiccated hills and valleys around 29 Palms acknowledge the natural processes of sun, wind, and too little rain that have over time determined the land's habitability. This dress rehearsal for a conflict that will later become all too real for these soldiers is taking place in the California desert where for centuries the Cahuilla, Chemehuevi, and Serrano Indians scratched out an existence, and the Spanish and American settlers dreamed of finding gold in the ground. This desert is not far from the Joshua Tree National Park, where lowly creosote bushes are still alive that took root many centuries before the birth of Christ.

It is breathtaking that Lê manages to focus on a CNN event, and simultaneously seems to pull back in a crane shot that overviews the thousands of wars, small and cataclysmic, that have blistered the earth. History has left countless scars on both landscapes and individuals. The mythic and luminous work of An-My Lê underscores how the art of photography, without disturbing the world, and by leaving behind only the thinnest imprints of human consciousness, can be a restorative act of nature and intelligence.

Notes

1 Stephen Jay Gould, in his book *Time's Arrow, Time's Cycle* (Cambridge, MA: Harvard University Press, 1987), is especially tough on the uniformitarians in general, and on Lyell in particular, for their reading of the fossil record, which, in Gould's expert opinion, offers far more support for the catastrophist position. In his magnum opus, *The Structure of Evolutionary Theory* (Cambridge, MA: Belknap/Harvard University Press, 2002), Gould further accuses Lyell of being more of a rhetorician than a scientist. Nonetheless, in most histories of science, Lyell is still considered "the father of modern geology."

2 In his 1844 book of text and photographs, *The Pencil of Nature*, Talbot suggested that his invention might be used in court as evidence against a thief who had stolen one or more of the objects in his Plate III, *Articles of China*.

3 Next to the Bible and art, Ruskin probably loved geology most of all, publishing his first paper on the subject at the age of fifteen. Among his mature writings, perhaps the five volumes of *Modern Painters* and his autobiography *Praeterita* contain his fullest appreciation of geologic knowledge as the basis for excellence in landscape painting.

4 For a thorough discussion of the various theories regarding O'Sullivan, King, and catastrophism, see Elizabeth Sarah Gene Paul's *Timothy O'Sullivan: Shadows of Subjectivity in the Photographer's Frame* (MA thesis, University of Virginia, 1999).

5 The exhibition was accompanied by a forty-eight-page book, *New Topographics: Photographs of a Man-Altered Landscape* (Rochester, NY: International Museum of Photography at George Eastman House, 1975).

6 *Second View: The Rephotographic Survey Project*, texts by Mark Klett, JoAnn Verburg, and Paul Berger. Photographs by Klett, Gordon Bushaw, Rick Dingus, et al. (Albuquerque, NM: University of New Mexico Press, 1984). Klett has subsequently worked with other teams and gone back again to the nineteenth-century sites,

results of which were published as *Third Views, Second Sights: A Rephotographic Survey of the American West* (Albuquerque, NM: University of New Mexico Press, 2004).

7 Sternfeld's project was published in book form as *On This Site: Landscape in Memoriam* (San Francisco: Chronicle, 1996).

8 Stephen Jacobs has photographed World War II reenactments in the eastern United States and is a devoted reenactor himself (portraying a member of a German Panzer unit). His work, undertaken during the same time but independently of Lê's, lacks her autobiographical component.

9 Tony Horwitz, *Confederates in the Attic: Dispatches from the Unfinished Civil War* (New York: Pantheon, 1998).

10 Jean Baudrillard's discussions of the concept of "simulacrum" are presented in several of his books, perhaps most famously in his 1981 essay "Simulacra and Simulation." See *Jean Baudrillard: Selected Writing*, ed. Mark Poster (Stanford: Stanford University Press, 1988).

11 This collaboration between Levinthal, as photographer, and Garry Trudeau, as writer, took place in 1973, when both were students (David was a graduate student and Garry an undergraduate) at Yale. Their joint effort was published as *Hitler Moves East: A Graphic Chronicle 1941–43* in 1977 (Kansas City: Sheed, Andrews and McMeel), and reprinted in 1989 (New York: Lawrence Miller Gallery, and Albuquerque, NM: University of New Mexico Press).

12 Michael Kimmelman, "Cartier-Bresson, Artist Who Used Lens, Dies at 95," *New York Times*, August 5, 2004.

13 The beginning of this movement is traditionally dated back to 1929 with the founding by Marc Bloch and Lucien Febvre of the journal *Annales d'histoire économique et sociale*; the influence of the École des *Annales* peaked after World War II under the leadership of Fernand Braudel and Emmanuel Le Roy Ladurie.

INTERVIEW: HILTON ALS

Hilton Als: For Americans born in the 1960s, Vietnam, or, rather, the "issue" of Vietnam—the "problem" of Vietnam—was something that we always lived with: on television, in newspapers, and the rest. But we did not necessarily understand what "the war" in Vietnam was about. Can you provide a thumbnail sketch of the historical and political background of your country, and the effect its invasions—by the French, by Americans—had on you, your family, and your environs?

An-My Lê: My mother's family—much more dominant in my life than my father's—was from Thai Binh, a small town near Hanoi. They lived through the Japanese occupation and under Communist rule. My mother grew up in Hanoi but for higher education traveled to Paris in the 1950s. In 1954, while she was still in Paris, my grandmother moved to Saigon when the country was divided at the 17th parallel and the Communists took over the North. My mother met my father and married him in Paris, where my older brother was born. They eventually returned to Saigon, where I was born.

We lived through many political coups, years of fear and uncertainty, as the Viet Cong would shell the city randomly every night. War became a routine, something we accepted as part of our lives, until 1968 when the Communists attacked Saigon during the Tet celebrations. They took over the American embassy and the radio station behind our house. This

offensive sent shock waves through the community. We all felt vulnerable. My parents decided we had to leave Vietnam to find shelter, even if it was for a short while. Fortunately my mother received a scholarship to work on a Ph.D. at the Sorbonne. We were able to move to Paris (my father stayed behind) and lived there for five years while she completed her Ph.D.

We returned to Saigon in 1973, only to see the country fall to the Communists in 1975. We were fortunate to be evacuated by the Americans that April. In spite of our ties to France, my parents decided to remain in the United States because it seemed to offer more opportunities at that time. For better or for worse, my life and those of the last three generations of my family have been underscored by the complicated political history of Vietnam.

Als: Your photographs deal so specifically with ideas of landscape; do you work from your memory of the Vietnamese landscape to examine your feelings about it, or to imagine what its colonizers might have felt about it?

Lê: Over the years, disconnected from the place and with only a handful of family pictures available, I had come to construct my own notions of a Vietnam drawn mostly from memories, but also from photojournalism and Hollywood films. In 1994 when I returned for the first time, I realized that I was not

particularly interested in reexamining contemporary Vietnam. Instead of seeking the real, I began making photographs that use the real to ground the imaginary. The landscape genre or the description of people's activities in the landscape lent itself well to this way of thinking.

My attachment to the idea of landscape is a direct extension of a life in exile. The sense of home has to do with the importance of food and location, and it is all connected to the land. Vietnam has always been (and still is somewhat) an agricultural society. Its culture and history are deeply rooted in its land. Growing up I did not know much of the country, actually not much outside of the capital and a few other large cities in the South, since it was difficult and unsafe to travel to the countryside during wartime. Especially when we lived in Paris and later in the U.S., I came to fantasize about this traditional agricultural way of life. Through folktales, legends, and many stories I heard from my mother and grandmother, I imagined a life that was truly magical but at the same time real and grounded— a life of hardship, working the land, with threats of war and disease but also the joys of living close to nature in a large, close-knit family.

Vietnamese society and in a way its people (especially in the North but partly in the South as well) have also been deeply scarred by years of immobilization and deprivation during the war and during the earlier part of the reunification. In the meantime, in spite of the destruction, the landscape

seems to have recovered and, to someone living in exile, has managed to retain and exude that sense of culture and history that can signal that one has arrived home.

The idea of the landscape and its climate was also such an important topic when the Vietnam War was covered in military analyses, news reports, and Hollywood films. The word *terrain* was often mentioned: how treacherous it was, how the enemy was better prepared for it and had a greater advantage. Working with the Vietnam War reenactors I became fascinated by the significance of the landscape in terms of its strategic meaning. Every hilltop, bend in the road, group of trees, and open field became a possibility for an ambush, an escape route, a landing zone, or a campsite.

In spite of the influence of Vietnamese culture on my life, I am also a product of colonial attitude, having grown up in a Francophile home and then later having lived in France. Eugène Atget has been a great inspiration—not only his work, which brilliantly captures the notions of change and transition in a place and a culture, but his entire life and working process.

Als: When did you begin your career in photography? And why?

Lê: It began by chance. I never felt I had a calling for anything in particular but was fairly good in the sciences, so I chose to study biology in college in preparation for a career in medicine. I was not accepted to any of the medical schools I applied to in my senior year, and it was suggested that I do biomedical research, publish, pursue a master's degree in biology, and reapply. While completing a master's at Stanford University, I wanted to take a drawing class to fulfill a nonscience requirement. It was full, so I chose photography instead. To my surprise, the class completely took over my life. If I was not photographing, I was in the darkroom printing until late. I loved every minute of it.

What drew me at first was simply how the camera gave me license to go out and discover more of the world; it taught me about people and places and about myself as well. The immediacy of responding to a situation when you snap your photo, the opportunity to be more analytical later when you edit the pictures, and the blend of the intuitive and the cerebral was very satisfying. Whatever a calling could be, it seemed to me that this was it.

In 1986 I moved back to Paris, where I floundered for a few months until Laura Volkerding, my teacher from Stanford, arrived. She came to document the casting of Rodin's *Gates of Hell* that had been donated to Stanford by Gerald Cantor. It was to be cast using the lost wax method at a foundry that belongs to a guild of craftsmen called the Compagnons du Devoir du Tour de France. The guild dates back to the Middle Ages and is comprised of various métiers: metalwork, masonry, stone-cutting, and carpentry/woodwork. These craftsmen were responsible for the construction of most churches and cathedrals in France. Now they do a lot of restoration work.

It turned out that the guild needed a staff photographer, and Laura referred me. I spent the next four years touring France and working for them. I was completely unprepared for the demands of this job; I quickly learned how to use a view camera on my own, how to use color film, how to light a space. I underwent a lot of trial and error. It was a great opportunity for me to travel and learn about the art and architecture of France, but more importantly, working for the guild deeply affected the way I saw things and represented them photographically. It was always about seeing clearly: showing the curve of a stairwell in an unencumbered way, the texture of this marble or that wood, drawing the volume of a vault in the most readable way. I also learned to respect the materiality of things (the nobility of stone, metal, and wood). I developed an appreciation of all things well made and a love for everything about the tradition of the craftsman and his work.

I moved back to the U.S., to New York City, in 1990. I finally realized that I did not want to be a commercial photographer and applied to graduate school. I then went to the Yale School of Art for my MFA. That's when I began to grapple with the scope of a possible life as a visual artist.

Als: After you began photographing, did you immediately establish long-range plans in terms of what you wanted to accomplish with it, such as your studies of the reenactors in "their" recreated Vietnam, or is it all a process of discovery?

Lê: It was all subconscious. I am rather amazed at how the three projects have come together as a sort of trilogy. Going into a project, I never know the photographs I will end up making. It is a process of discovery, and I try to stay as open-minded as possible. For me it is first about learning something about the world, about myself. It is a little frightening starting a project in such a way and not feeling prepared, but so much of it is about problem solving. I am always asking myself what it is I am trying to find out about the situation, about the people: What does it all mean in terms of a cultural and historical context? What are my personal issues here? What is the point? Is it worthwhile? What kind of photographs could attempt to broach and perhaps begin to answer those questions?

The Vietnam project happened in 1993 after graduation from Yale, where I had been encouraged to do work that was more personal and autobiographical. The U.S. was loosening its diplomatic and economic relations with Vietnam. I saw the opportunity to return to Vietnam, which is something we never thought we could do when we left in 1975. The question of war was not central to the photographs I made in Vietnam.

Only at the conclusion of this project did I feel ready to tackle that issue head-on. I had to also ask myself: how do you address something that has happened so long ago? I felt stumped; other than working with press images or trying to memorialize the event, what could I do?

Some of what I did in Vietnam, where I learned how to place people in the landscape, prepared me for the subsequent series. I learned that it is all about scale. How far back can you go to get a great drawing of the land, while still being able to suggest the activity of the people?

Als: How did you find out about the "reenactments"? And what was your first response to them? Did you have to go through a great deal of bureaucratic rigmarole to gain access to photograph?

Lê: I had heard about these small, low-key groups of men who reenact the Vietnam War. After some research on the Internet, I found one group based in Virginia and contacted them. It was smaller and more exclusive when I first worked with them than it is now. Gaining an invitation to the first event involved a lot of back and forth emailing with the founder. Once I was there, it became a lot easier because it was clear I wanted to help contribute to the event as best as I could while making my photographs.

Als: Did you actually become involved in any of the war games that you documented?

Lê: Yes, that's the requirement for attending the events, which last three days. The reenactors are obsessed with re-creating a situation that is seamless. So it is crucial that everything—from the erection of Viet Cong villages and GI firebases to a haircut and the smallest details in a uniform—be of the period. To fit in I often played a VC guerilla or North Vietnamese army soldier. I did what I needed to do to find the right VC uniform, sandals, rucksacks, and hammock. To go on the GI side, I would become a "Kit Carson" scout, a turncoat who would inform the Americans.

The reenactors truly enjoyed having me there. I added to the authenticity of the event, and they would often concoct elaborate scenarios around my character. I have played the sniper girl (my favorite— it felt perversely empowering to control something that I never had any say in). I have been the lone guerilla left over in a booby-trapped village to spring out of a hut and ambush the GI platoon. I have played the captured prisoner.

Initially I was terrified at the prospect of spending three days with these unknown men on a hundred-acre private property ten hours from New York City. My friend Lois Connor accompanied me. It turns out the reenactors are straightforward, conservative men who are so dedicated to this hobby. It's an obsession for many of them—an obsession with collecting

and trading all the paraphernalia, meshed with an interest in military history. Reenacting events are an opportunity for them to put their stuff to use, meet other men who share their interest, and live in a kind of virtual reality or travel back in time, all while having an adventure with their buddies.

From many conversations, I also learned that their interest in the military and in Vietnam stemmed from complicated personal histories. These men came from all sorts of professions. A few had been in the military, but rarely did they have experience in a combat situation. Some had missed their calling for the military and were steered by their parents toward law school or business school; some had lost a brother in Vietnam. I met at least two men whose fathers had distinguished themselves in combat in Vietnam. It seemed that many of them had complicated personal issues they were trying to resolve, but then I was also trying to resolve mine. In a way, we were all artists trying to make sense of our own personal baggage.

Als: How did you develop the topic of the third series?

Lê: In 2002 and 2003 the U.S. was gearing up for the war in Iraq and Afghanistan just as I finished working with the reenactors. I was extremely distressed the day the war began in March 2003. Strangely enough, my heart did not go out immediately to the Iraqi civilians, but to our troops. I first thought of the scope and impact of war on them and their extended families. I am not categorically against war, but I feel the decision makers and policy makers have no idea how devastating the effects of war can be. Remembering my own experience, I also felt completely vulnerable. War just seemed unreasonable and unjustified in this case.

Trying to make sense of all this, I decided I had to find a way to go to Iraq. It was, unfortunately, too late to become embedded. I came across a photograph of the Marines training in the California desert in 29 Palms that looked just like parts of Afghanistan and Iraq. I immediately knew this place held great potential for a new project. Working there would follow with the idea of the reenactment and training for something. I was also drawn by the concept of simulations that are once removed but allow one to see and understand the real thing with clarity and perhaps more objectivity.

Once I began photographing at the Marine Air Ground Combat Center in 29 Palms, it became obvious that my pictures stand in complete opposition to combat photography. We are dealing with parallel subjects, but the outcome—the meaning—is completely different. In the case of combat photography, the die is cast. The photographer is thrown into a conflict where his work is about capturing the action or the aftermath. Chaos, the horrific violence of the moment, and the obvious risk incurred by the photographer in this situation all play into producing an image with a brutal if not blinding immediacy. Conversely, working with the military in training allows for breathing room. What jumps out for me is the way in which the magnitude of the firepower used—from artillery weapons to mortars, C-4 explosives, and air-delivered bombs—and its destructive potential, becomes muted and transformed as it is photographed in these exercises in the middle of a tranquil desert. One can then step back and ponder the larger issues of war. For me the question is not only are we militarily ready, but also are we politically, morally, and philosophically prepared? No, we are not. This project is an impassioned plea for a much-needed consideration of the consequences of war.

Als: Have you looked at a great many war photographs? And do you agree with many photography critics when they say that photographs of war "depersonalize" pain? By working with "staged" coups and so on, does that distance Vietnam for you?

Lê: I am a great admirer of the nineteenth-century war photographers, but I also respect the more contemporary ones: Robert Capa, Larry Burrows, James Nachtwey, Gilles Peress, Tyler Hicks. I have

studied the work of many North Vietnamese combat photographers. In a way I feel closer to them and the nineteenth-century European photographers because of the importance they give the landscape in their work.

I do think the current photos of war from Iraq and Afghanistan (except for the Abu Ghraib pictures, which were not made by professional photographers) are a lot more tame and feel more glossy than anything ever made in Vietnam, but it's also true that our hearts are colder these days from having been bombarded with one agonizing and horrific picture after another. In the end I think it is the cumulative effect of the images over time that will have as much effect on us as the single image of the young Vietnamese girl burned by a napalm bomb.

The more contemporary photographs that capture the immediate moment certainly convey the devastation and pain, but they are usually so horrific one has to turn away in shock—they go more to your gut than to your head. In the end these photographs certainly remind us we are at war, but how thought provoking are they?

I am more interested in the precursor to war and its psychic aftermath. There is something about addressing the preparation for war or the memory of war itself that allows one to think about the larger issues of war and devastation. Again, how prepared are we? And what are the effects of war on the landscape, on people's lives? How is war imprinted in our collective memory and in our culture? How does it become enmeshed with romance and myth over time (i.e., for Hollywood and for the reenactors)? My concern is to make photographs that are provocative in response to the reality of war while challenging its context.

Als: Of course, all photographs lie. I consider pictures to be metaphors for actual events and the people in them. For me, photographs capture something—an essence—of an event or a person, but selectively. Given the pictorial and emotional scope of your work, how do you set about capturing such a large portion of our collective political history?

Lê: Great landscape photography has a literal but also a metaphorical scope to it (Atget, Robert Adams, etc.). There is something about seeing people's lives (or the suggestion of it) splayed across a landscape that can be breathtaking and unforgettable. There is no escaping the specificity of photography, but I aspire to achieve a certain lyrical objectivity. It is more about patterns of behavior than the specificity of it, which perhaps allows for a larger understanding of history and culture. August Sander and Judith Joy Ross manage to do this through portraiture. Here it is landscape photography that gives me that opportunity. It allows for descriptive possibilities. You can ascribe character to a landscape; you can suggest its usage. It is like a stage and, most importantly, I try to not let the people and their activities completely take over.

Als: Why do you shoot in black and white? And what kind of camera do you use?

Lê: I always consider all possible tools at the beginning of a project (color or black-and-white film; small-, medium-, or large-format cameras). But so far, the 5-by-7-view camera has been my tool of choice, in spite of its inconveniences. It provides a great large negative full of details. It allows for a certain clarity and descriptive sharpness. Above all, in an image from 5-by-7 negatives or larger, one can sense the volumes of air moving between things and inside spaces. I tend to prefer black and white because I am very interested in the way things are "drawn." This is much more apparent in black and white, where the palette is reduced simply to black, white, and various shades of gray. The world as seen in black and white also feels one step removed from its reality, so it seems fitting as a way to conjure up memory or to blur fact and fiction. Most of my memories of the Vietnam War, aside from what I witnessed firsthand, derive from black-and-white television news footage and black-and-white newspaper images.

The 5-by-7 view camera is very clunky because of its size, weight, numerous accessories, and the

need for a tripod. You can't work that spontaneously. All shots have to be somewhat premeditated and directed, especially those involving people, because of slow shutter speeds and delay between framing the image and closing the shutter/cocking the lens/exposing the film. A lot of this accounts for the pictures in all my projects seeming staged. There were situations where I had to photograph what was in front of me, but there were also times when I had an idea and went about constructing the scene from scratch (using the setting and prop of choice, choosing the people, and directing them). Working this way—either planning something from scratch or anticipating something before it happens—feels much more cerebral. We often say that photographers hide behind their cameras. In a way the view camera has provided me with multiple shields from the painful memory of war, while allowing me to come as close as possible to try to understand it.

Als: Some of your pictures look like film stills; have you looked at a lot of narrative and documentary films about Vietnam in preparation for your work?

Lê: If they resemble film stills, most are more in the vein of the establishing shots—those that situate everything. I have always looked at Vietnam War films. (Well, only starting in the mid-eighties—it was

too soon and still somewhat too traumatic before then.) I was interested in seeing how something that I knew so well, something that affected me so deeply, was portrayed on screen. Watching these movies was also the only opportunity to get a glimpse of "Vietnam." Even when another country or Chinese actors were used as stand-ins, any suggestion of the country, its life, and its people satisfied my curiosity (and tempered my homesickness and yearning). *The Anderson Platoon,* a documentary by Pierre Schoendorffer, and of course *Apocalypse Now, Full Metal Jacket, Casualties of War, Platoon*—the first three are my favorites. More recently, I have seen these movies with a completely different interest in mind. I am interested in the Vietnam of the mind. It's fascinating to me how all these other countries (Thailand and the Philippines mostly) are stand-ins for Vietnam and how the landscape has become a character.

I have been paying attention to how the cinematography is used to conjure up the past. The idea of the period piece is an interesting conceit. Many people find the activities of the Vietnam War reenactors very disturbing. Comparatively, Hollywood's obsession with the Vietnam War and its numerous, painstaking "reenactments" on film seem completely reasonable. For me the fascination lies in the dialogue these two worlds establish between experience and chaos versus memory and storytelling.

These days, young Americans are first introduced to the subject of Vietnam, the Holocaust, or World War II by movies like *Schindler's List, Saving Private Ryan,* or *Apocalypse Now,* and only later (or maybe never) will they learn the hard historical facts in textbooks in a classroom situation. From the start, there is a blurring of fact and fiction that's fascinating.

I draw my motivations for these projects from personal memories and from both a fascination and an aversion for anything that has to do with war and destruction, for the military, paramilitary fringe groups. Mix into that an interest in mediated images in popular culture—all of these influence the way my pictures look: they could be as much about my memory of GIs walking down Tu Do street in Saigon as an echo of the depiction of the Air Cavalry machos in *Apocalypse Now.* I consider my work an inquiry into the literal representation of things vs. depictions that live in popular imagination.

Als: How did you feel at the end of these various projects? Did you feel as if you had "come home" in a sense? Has this work helped you deal with your origins?

Lê: It's interesting that you ask about "coming home." I've been obsessed with that idea because it applies to the type of fieldwork I do as a photographer as much as it is relevant to

the experiences of the refugee and the soldier. Ambiguity and contradictions—the conflict between expectations and memories—these are all built into the experience of coming home for a refugee, for a soldier (whether from a real or virtual battle), or even for a photographer. Whether it is a childhood abruptly ended or a violently murderous week-long siege during the battle of Khe Sanh, some of us are confronted with these intense life experiences. They're defining experiences that echo throughout one's life. Whether coming home, returning to the country of origin for the refugee, going back to civilian life for the soldier, one is compelled to construct a story for oneself and hopefully come to terms with what happened. In attempting to construct a coherent narrative, one must negotiate a contentious and sometimes contradictory terrain, reconciling one's own experience with other people's ideas of it and against general expectations. It's about understanding how one's experience fits into the larger scheme of things and finding a personal equilibrium within that.

And as a photographer, there's another layer—I have a different relationship to memories than the refugee or the soldier because through the work, there is potential for tangibility. I am the type of photographer who is interested in the way things look and in letting that be my major story-telling device. In that pointed moment it allows one to raise pertinent questions and to ponder the larger issues involved.

Crudely, my work is about reconciling what I thought I was getting myself into and what is actually revealed to me in the field. It's not about taking a specific stand, or dignifying something that is important to me—nor is it about exalting a specific cause I'm committed to or exploring a subculture in depth. I'm satisfied in simply addressing these subjects: Vietnam, the military and the glamour of war, cultural and political history, and small subcultures. Photography becomes the perfect medium for conjuring up a sense of clarity (if not necessarily the truth) in the midst of chaotic and polarizing subjects.

An-My Lê

Born 1960 in Saigon, Vietnam; lives in New York

Education

1993 MFA Yale University School of Art, New Haven, CT

1985 MS Stanford University, Stanford, CA

1981 BAS Stanford University, Stanford, CA

Solo Exhibitions

2004 *29 Palms*, Murray Guy, New York, NY

2002 *Small Wars*, PS1/MoMA Contemporary Art Center,
 Long Island City, NY

1999 *Vietnam*, Scott Nichols Gallery, San Francisco, CA

Selected Group Exhibitions

2005 *The Art of Aggression*, Reynolds Gallery, Richmond,
 VA and traveling

2004 *Reinstallation of the Permanent Collection*, Museum of
 Modern Art, New York, NY

 The Freedom Salon, Deitch Projects, New York, NY

2003 *Only Skin Deep*, International Center for Photography,
 New York, NY

2002 *Fiona Banner, An-My Lê, Ann Lislegaard*, Murray Guy,
 New York, NY

 Road Trip, Murray Guy, New York, NY

 Gravity Over Time, Milleventi gallery, Milan, Italy

2000 *Documents, Perceptions, and Perspectives*, Rhode
 Island College, Providence, RI

1999 *Things They Carry*, University of North Texas Art
 Gallery, Denton, TX

1998 *Re-imagining Vietnam*, Fotofest, Houston, TX

1997 *Selections from the Permanent Collection,*
 San Francisco Museum of Modern Art,
 San Francisco, CA

 New Photography 13, Museum of Modern Art,
 New York, NY

 Picturing Communities, Houston Center for
 Photography, Houston, TX

1994 *Building, Dwelling, Thinking*, Lowinski Gallery,
 New York, NY

Awards/Grants

2004 John Gutmann Photography Fellowship

1997 John Simon Guggenheim Memorial Foundation
 Fellowship

1996 New York Foundation for the Arts Fellowship in
 Photography

1995 CameraWorks Inc. Fellowship

1993 Blair Dickinson Memorial Award, Yale University
 School of Art

Collections

Bibliothèque Nationale, Paris; Dallas Museum of Art, Texas;
Herbert Johnson Museum, Cornell University, Ithaca,
New York; Metropolitan Museum of Art, New York; Museum
of Fine Arts, Houston; Museum of Modern Art, New York;
Museum of Modern Art, San Francisco; Sackler Gallery of Art,
Smithsonian Institution, Washington D.C.; Whitney Museum
of American Art, New York

Bibliography

2004 Aletti, Vince. "An-My Lê." *Village Voice*, October 6–12,
 2004, p. 151.

 Cotter, Holland. "An-My Lê." *New York Times*,
 September 24, 2004, p. E33.

 "The faces of the future." *Art Review*, (October 2004):
 89 (illus.).

 Gopnik, Blake. "For Art Lovers, A Chelsea Morning."
 Washington Post, September 26, 2004, p. N01.

 Kerr, Merrily. "An-My Lê: 29 Palms." *Time Out
 New York*, Issue No. 472, October 14–21,
 2004, p. 80.

 Moylan, Chris. "An-My Lê: 29 Palms." *Art AsiaPacific*,
 No. 43 (Winter 2005).

 New Yorker, October 4, 2004, p. 21.

 Rosenberg, Karen. "An-My Lê—Murray Guy."
 Artforum (November 2004): 225–26.

 "Small Wars," *Blind Spot,* Issue 28.

 Terranova, Charissa. "Manhattanism." *Dallas
 Observer*, October 28, 2004.

 Vanderbilt, Tom. "An-My Lê: 29 Palms." *Artforum*
 (December 2004): 170.

2003 Fusco, Coco. *Only Skin Deep*. International Center
 of Photography-Harry N. Abrams, 2003, p. 74
 (illus.).

2002 Aletti, Vince. "Voice Choices—Photo." *Village Voice,*
August 28–September 3, 2002, p. 67.

"Art museums & galleries." *San Jose Mercury News,*
June 16, 2002, p. 8E (illus.).

2001 Lê, An-My. "Small Wars." *Cabinet* (Spring 2001).

"Small Wars," *Trace #1, AIGA Journal* (January 2001).

2000 "Vietnam." *DoubleTake Magazine* (Spring 2000).

1999 Daniel, Mike. "Vietnam War revisited." *Dallas Morning
News*, October 22, 1999.

Harper's (July 1999): 37 (illus.).

Scott, Whitney. "Must museum." *New York Post,*
January 10, 1999, p. 27 (illus.).

Whiting, Sam. "Datebook: Impressions of Postwar
Vietnam-photographs by Vietnamese American
An-My Lê." *San Francisco Chronicle,* May 10,
1999, p. E1, p. E5.

1998 Maning, Dee. "Central's FAC host to 'Re-imaging
Vietnam'." *Egalitarian,* April 8, 1998, p. 13.

"Goings On About Town." *New Yorker* (January 12,
1998): 18 (illus.).

1997 Cotter, Holland. "Art In Review: 'New Photography
13'." *New York Times,* November 7, 1997, p. E37.

"Critic's Picks." *Time Out New York,* October 23–30,
1997.

1994 Aletti, Vince. "Building Dwelling Thinking." *Village
Voice,* March 1994.

Chadwick, Susan. "Through Asian-American Eyes."
The Houston Post, November 4, 1994.

Sorensen, Edith. "Press picks." *Houston Press,*
November 17–23, 1994, p. 20.

Richard B. Woodward

Richard B. Woodward has been a visiting critic in photography at Columbia University's Graduate School of the Arts, Rhode Island School of Design, and elsewhere. He has written extensively about the arts for the last twenty years, contributing essays to monographs on David Levinthal, Lee Friedlander, William Eggleston, and Abelardo Morell. His articles on photography have appeared in the *New York Times*, *New York Review of Books*, *Atlantic Monthly*, and the *Village Voice*.

Hilton Als

Hilton Als has been a staff writer for the *New Yorker* since 1996 and is a former arts editor for the *Village Voice* and editor-at-large of *Vibe*. Mr. Als is the recipient of a 2000 Guggenheim Award for creative writing and author of *The Women* (2003).

The book is supported by the Jerome Foundation in celebration of the Jerome Hill Centennial and in recognition of the valuable cultural contributions of artists to society.

Small Wars also received support from the Lannan Foundation, Santa Fe, New Mexico.

Acknowledgments

The completion of this book was made possible through generous support from the following individuals and institutions:

Susan Kismaric, John Pilson, Ted Partin, Richard Benson, Stephen Shore, Lois Conner, Judith Ross, Ed O'Dowd, Sam Morgan, Reka Reisinger, Timothy Karr, Kathy Charlton, Tod Papageorge, Patrick Lannan, Phan Cam Thuong, Nguyên Manh Duc, David Thomas, Mitch Epstein, Russell Bong, Andrew HIller, Kevin Dawson, and MHEC, Hilton Gray and his group, Major Robert Crum, Major James Mc Arthur, Major Matthew Denney, Sergeant Jennie Haskamp, Lieutenant Christy Kercheval, Gunnery Sergeant Frank Patterson, the Marines of the 29 Palms Marine Air Ground Combat Center, Colonel Thomas Greenwood, Captain Manuel Delarosa, Gunnery Sergeant Robert Knoll, the Marines of the 15th Marine Expeditionary Unit, the John Gutmann Fellowship, the Bard College Research Fund, the John Simon Guggenheim Memorial Foundation, the Joy of Giving Something, Inc., the New York Foundation for the Arts, and the Yale University Blair Dickinson Memorial Fund.

I am grateful to Laura Volkerding for her early encouragement and to my family for their continued support.

Front cover: *Untitled, Ho Chi Minh City, 1998*
Back cover (from left to right): *Untitled, Son Tay, 1998*, from "Viêt Nam"; *Rescue, 1999–2002*, from "Small Wars"; *Colonel Greenwood, 2003–4*, from "29 Palms"

Editor: Lesley A. Martin
Designer: Andrew Sloat
Production: Lisa A. Farmer

The staff for this book at Aperture Foundation includes: Ellen S. Harris, *Executive Director*; Michael Culoso, *Director of Finance and Administration*; Lesley A. Martin, *Executive Editor, Books*; Nancy Grubb, *Executive Managing Editor, Books*; Lisa A. Farmer, *Production Director*; Andrea Smith, *Director of Communications*; Kristian Orozco, *Director of Sales and Foreign Rights*; Diana Edkins, *Director of Special Projects*; Blair Knobel, *Work Scholar*

Illustration credits: page 110, courtesy George Eastman House, Rochester, New York; page 112, copyright © Robert Adams, courtesy Fraenkel Gallery, San Francisco, California; page 114, courtesy Collection of The New-York Historical Society; page 116, courtesy George Eastman House, Rochester, New York

First edition
Printed and bound in Italy
10 9 8 7 6 5 4 3 2 1

Library of Congress Control Number: 2005923966
ISBN 1-931788-82-0

Aperture Foundation books are available in North America through:
D.A.P./Distributed Art Publishers
155 Sixth Avenue, 2nd Floor
New York, N.Y. 10013
Phone: (212) 627-1999
Fax: (212) 627-9484

Aperture Foundation books are distributed outside North America by:
Thames & Hudson
181A High Holborn
London WC1V 7QX
United Kingdom
Phone: + 44 20 7845 5000
Fax: + 44 20 7845 5055
Email: sales@thameshudson.co.uk

aperturefoundation
547 West 27th Street
New York, N.Y. 10001
www.aperture.org

The purpose of Aperture Foundation, a non-profit organization, is to advance photography in all its forms and to foster the exchange of ideas among audiences worldwide.